CARCHITECTURE

FRAMES, FENDERS, AND FINS

CARCHITECTURE

500 Photographs

FRAMES, FENDERS, AND FINS

Fredric Winkowski
Text by Frank D. Sullivan

Glitterati
INCORPORATED

New York, New York

First published in the United States of America in 2008 by Glitterati Incorporated

Glitterati
INCORPORATED

225 Central Park West, New York, New York 10024
Telephone 212-362-9119/Fax 212-362-7174
www.GlitteratiIncorporated.com

First edition, 2008
Library of Congress Cataloging-in-Publication data is available from the Publisher.
ISBN-13 978-0-9793384-8-9

Design: Sarah Morgan Karp, smk-design.com

Printed and bound in China by
Hong Kong Graphics & Printing Ltd.

10 9 8 7 6 5 4 3 2

Dedication

To the memory of my Aunt Mimi, for the unconditional love and support she always gave me. —Frank

To the memory of my father Felix, who long ago introduced me to the mysteries and pleasures of photography. —Fred

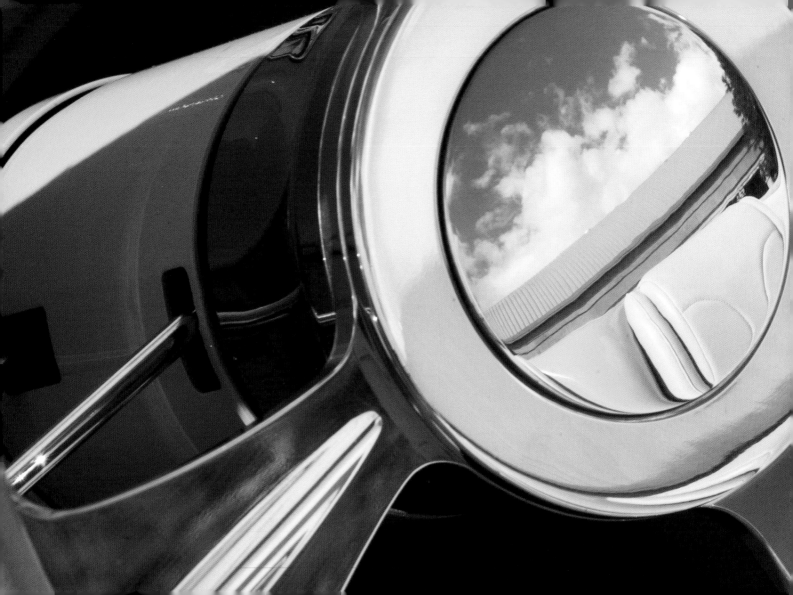

CONTENTS

Car Talk WITTICISMS, QUOTES, AND QUIPS 8
Introduction FRANK D. SULLIVAN AND FRED WINKOWSKI 10

Chapter One CURVES 18
Chapter Two LINES 42
Chapter Three SYMMETRY 68
Chapter Four REFLECTIONS 88
Chapter Five TRANSPARENCY 114
Chapter Six LIGHTS 134
Chapter Seven COLORS 164
Chapter Eight EMBLEMS 190
Chapter Nine METAPHORS 224
Chapter Ten ARTICULATED 248
Chapter Eleven INTERIORS 278
Chapter Twelve ENGINES 304
Chapter Thirteen STYLE 328

Index 350
Acknowledgments 352

opposite, Ford, Custom Hot Rod, 1933; half title page, Hudson, 1913

Witticisms, Quotes, and Quips

"Everything in life is somewhere else, and you can get there in a car."
—E. B. White, *One Man's Meat*

"Except for the American woman, nothing interests the eye of the American man more than an automobile, or seems so important to him as an object of aesthetic appreciation."
—Alfred Hamilton Barr, Jr.

"Automobiles are free of egotism, passion, prejudice, and stupid ideas about where to have dinner. They are, literally, selfless. A world designed for automobiles instead of people would have wider streets, larger dining rooms, fewer stairs to climb, and no smelly, dangerous subway stations."
—P. J. O'Rourke, "An Argument in Favor of Automobiles vs. Pedestrians"

"No other man-made device since the shields and lances of the ancient knights fulfills a man's ego like an automobile."
—Sir William Rootes

"I think that cars today are almost the exact equivalent of the great Gothic cathedrals: I mean the supreme creation of an era, conceived with passion by unknown artists, and consumed in image if not in usage by a whole population which appropriates them as a purely magical object."
—Roland Barthes, "The New Citroën"

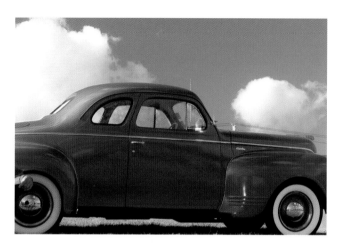

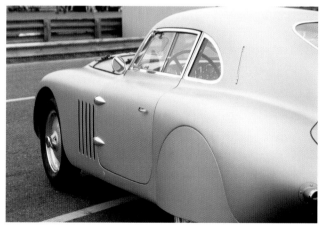

top, Plymouth, Business Coupe. 1941; bottom, BMW, Mille Miglia, 1940

"It is valid to consider the automobile an object of popular art, and to interpret its appearance as an expression of the culture and period that produced it."
—Paul C. Wilson, *Chrome Dreams*

"Auto racing, bullfighting, and mountain climbing are the only real sports . . . all others are games."
—Ernest Hemingway

"A car can massage organs, which no masseur can reach. It is the one remedy for the disorders of the great sympathetic nervous system."
—Jean Cocteau

"Driving is a spectacular form of amnesia. Everything is to be discovered, everything to be obliterated."
—Jean Baudrillard

"Glorious, stirring sight! The poetry of motion! The real way to travel! The only way to travel!"
—Kenneth Grahame

"The car has become an article of dress without which we feel uncertain, unclad, and incomplete."
—Marshall McLuhan

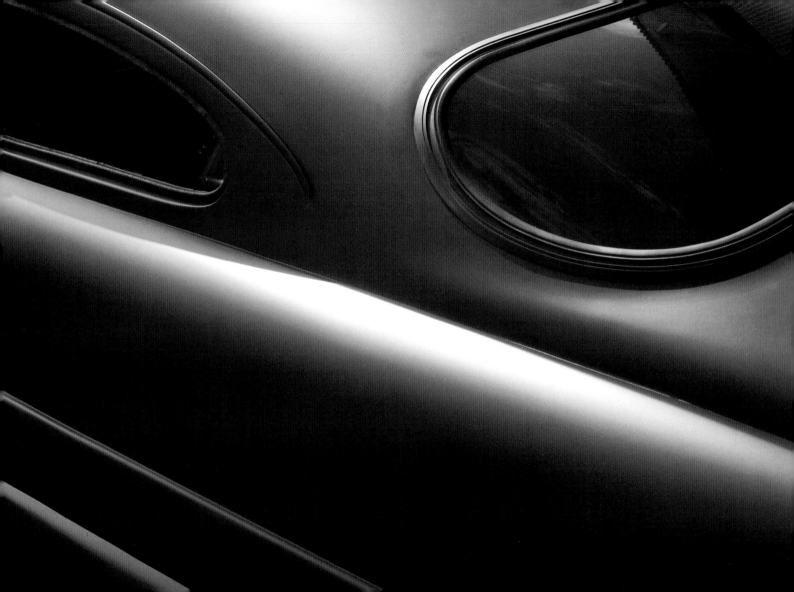

It's been said that architecture must speak to us, and the same is true of some special cars. Admittedly, it's an odd conceit: cars as architecture. But automobile design and architecture do share some attributes. Both are works of public art—out in the street for all to see. Both architects and automobile designers are professionals who must possess not only an artist's eye but the mind of an engineer, as well. The best of the best, like Frank Lloyd Wright's *Fallingwater* (1935) and Gordon Beuhrig's Cord 810 automobile from the same year, hold up ideals of proportion and symmetry and are measured and judged according to their function and economy. Most importantly, both buildings and cars can function as powerful symbols. From the beacon of hope that the UN building represents, to the more mundane symbol of greed, which the supersize SUV has become, our photos illustrate how autos can embody so many meanings in their every component.

Both Fred Winkowski and myself were young boys in 1950s, car-mad America, so we have always regarded these machines with a bit of awe. Every ad and commercial during those years proclaimed the beauty of the fall season's new crop of cars, and it was exciting to spot them "on the hoof." Being city kids, this was street art for us, much more immediate than pictures in a museum.

Frank was especially taken by a promotional pamphlet called Styling the Look of Things, which was produced by the public relations department of General Motors in 1956. The booklet gave a General Motors–centric view of the basic evolution of

modern design, and of automobile design in particular. This pamphlet made such an impact on Frank, who was then in high school, that it set him on the path to becoming an industrial designer. *Carchitecture: 500 Photographs from Frames to Fins* pays homage to that inspiring old booklet.

Cars Are Born

If anything, the earliest cars had more in common with folk architecture. Even though the engine technology was state of the art for the time, metalwork was often at the village smithy level. Wheels and chassis followed the age-old practices of carpenter and wheelwright. But their builders' genius lay in making their contraptions run and optimizing them for production, not in giving a new form to a revolutionary means of transport. The best of these budding designers realized that their autos were not industrial machinery; they had to be sold to novice motorists, who needed to feel comfortable with the new vehicles. So they co-opted the structure and the style of the carriage or buggy, the wood-spoked wheels, the thin wood-veneer lacquered bodywork, and the ogee curves and filigreed decoration. It was a natural enough move, but manufacturers were basically repurposing a design that had already existed for centuries. These first motorized carriages led Italian designer Pininfarina, fifty years later, to quip, "Cars were born old."

Gradually, a unique vocabulary of form evolved for the automobile. Shaped by the demands of speed and of forward motion, the engine moved up front—a wedge-shaped box,

Mercury, 1951

with the erect, high-topped passenger enclosure behind. Between the blocky body forms and the circular wheel disks rode the long, linear outriggers of the fenders or mudguards. Arbiters of this new architecture were custom bodybuilders, themselves scurrying to switch from crafting horse-drawn carriages to designing these new machines.

The most successful of these houses—Mulliner, Windover, Labourdette, and Rothschild and Fils in Europe, and Brewster, Murphy, and LeBaron in the United States—could manipulate the classic elements of body and fender to evoke anything from feral grace to swanky opulence. And these fashions, for that is what they were, gradually percolated downward to the mass-produced machines. Soon the long torpedo bodies, the sweeping clamshell fenders, were seen everywhere.

The New Spirit

So things went until the early 1920s, when sculptors and architects, renewed by a ferment in the arts—which was quiescent during World War I—again drew inspiration from cars and aircraft and the industrial landscape. One architect in particular, Charles-Edouard Jeanneret-Gris, who chose to be known as Le Corbusier, was particularly smitten with cars. In his writings, especially in his book, *Towards a New Architecture* (1923), he pleads for architects to learn from the functionality and simplicity of automobiles, steamships, and airplanes. He championed the use of mass-production techniques in developing what would become known as the international style of architecture. Famous for declaring that "the house is a machine for living in," and vilified by some for advocating dehumanizing cities comprised of rows and rows of identical skyscrapers, Le Corbusier was not neglectful of "the needs of the heart," as he called them, though he disdained sentimentality and slavish reuse of the designs of the past. He believed in a starker, more cerebral appeal to emotion expressed through logic, proportion, and imagination. By juxtaposing pictures of the Parthenon with photos of exciting motorcars in his book, he hoped to inspire a reinvention of the noble art of architecture. He also tried his hand, somewhat timidly, at designing cars himself for his friend, French auto manufacturer Gabriel Voisin.

Ironically, his automotive examples, so foursquare and upright, so beautifully proportioned in plan and elevation, were among the last of their kind. The car began to draw inspiration for its shape from the aerodynamic curves of new all-metal airplanes that took wing in the late 1920s. It was the birth of streamlining. Autos had no real need for these trappings of speed, but the lure of the teardrop shape and the symbolism of the speedline were impossible to resist in a world gone mad for the futuristic world of streamlining.

So architecture consolidated the austere rectilinear style that would hold sway until the present day. Likewise, product design emerged as a logical, rational aesthetic discipline embracing mass-production techniques as put forth by the Bauhaus, the German craft and design school founded by architect Walter Gropius, who incidentally designed a few autos himself. Nevertheless, the world of car design, though clearly influenced by these principles, has always gone its own singular way.

The Rise of the Studio

Even though Harley Earl was only too happy to proclaim himself the founder of modern car design as practiced by large corporations, this was, by and large, the truth. Hired away by General Motors from a lucrative business building custom-bodied luxury autos for Hollywood notables, Earl was expected to add a little style and class to the firm's stable of autos. This he did, but he also built his in-house design studio, pretentiously named the Art and Colour Section, into a power base. He was then able to confront on equal terms what he saw as narrow-minded engineering, production, and accounting departments. His initial from-the-ground-up design, the 1927 LaSalle, proved to be a hit, the first in a long string. Earl expanded his staff, institutionalizing the use of clay models, a medium that could quickly demonstrate new curvilinear, streamlined designs, and beginning the use of one-off "dream cars" for putting new ideas before the public.

Other carmakers, which had been relying on individual efforts and freelancers for their designs, were forced to adapt General Motors' studio practices. This transition was all but complete by the time of the 1939 World's Fair. Those U.S. automakers remaining after the Depression, General Motors, Ford, and Chrysler, known as the Big Three, allied their stylists with industrial designers and architects who, along with the rest of corporate America, staged a futuristic carnival of wish fulfillment in New York City as World War II approached.

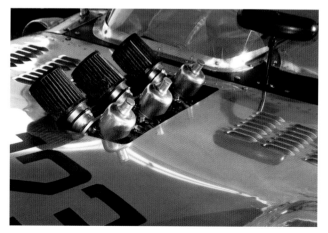

top, Ford, 1937; bottom, Philson-Falcon, 1959

By mid-century General Motors' styling staff was housed in a vast campus, the Technical Center, designed by noted modernist architect Eero Saarinen. Harley Earl's brand of car design seemed to coincide brilliantly with the American driver's wishes until the late 1950s. Then, nudged by a major recession and low-priced competition from "foreign" cars such as Volkswagen's Beetle, U.S. automakers went off the rails into a manic period of overdesigned, overweight excess. By this time, the annual cosmetic model change and the idea of "planned obsolescence" permeated all of the U.S. consumer market. Critics began to point out deep flaws in the system with books such as Vance Packard's *The Hidden Persuaders* (1957) and John Keats's *The Insolent Chariots* (1958). Most outspoken of all was Ralph Nader's *Unsafe at Any Speed* (1965). So, changes were implemented, designs were toned down, and attempts were made to produce smaller, more economical cars. In fact, as Harley Earl's successor, Bill Mitchell, took over, some truly classic designs such as the Corvette Stingray and Buick Riviera showed a clean, fresh approach to American car design. But like an addictive drug, the high of selling sex and power was too much to resist. The industry-wide embrace of the muscle car in the late 1960s produced some gorgeous vehicles but proved to be exactly the wrong move as the world economy headed south.

The pop art movement of the 1960s, however, took a new look at car design and the roadside landscape and saw much to admire. Architect Robert Venturi's *Learning from Las Vegas* (1972) and social critic Reyner Banham's writings, though laced with a tongue-in-cheek campy cynicism, gave the automobile a new credibility. Cars became pop icons.

The truth is, now that these years are long past, most of the world just loves the old 1950s and 1960s chariots. They won't go away—they still speak to us: colorful, chromed dreams, optimistic all-guns-blazing assaults on the future.

Postmodernism

The demoralizing decade of the 1970s, notable for gas crises, stagflation, and the chaotic end of the Vietnam War, produced some handsome auto designs such as the Volkswagen Rabbit, but government regulation and labor problems ensured that most design was timid, derivative, and repetitive. Think of Chrysler's endless variations on its "K" car. But as the economy roared back in the 1980s, greed was good, and so was style.

Seemingly taking its cue from the revitalization of architecture's postmodern movement along with design as typified by the Italian "Memphis" group, and helped along by some much welcomed prosperity, car design showed signs of a renewed exuberance in the 1980s. Ford, made bold by economic desperation, embraced radical aerodynamic shapes, as typified by the Taurus. Though put down as the "jellybean" by some, Jack Telnack's watershed design saved Ford; it was endlessly copied, and best of all, it killed off the last of those slab-sided econoboxes of the 1970s. Taurus also marked the start of the era of the computer as the design tool of choice for the industry,

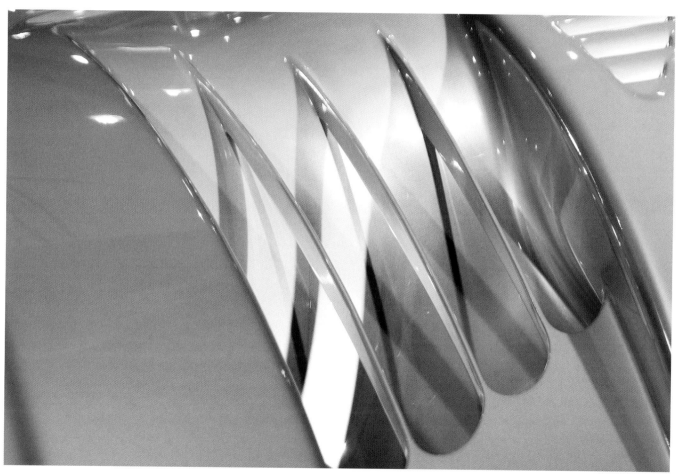

Maserati TNC-2. 2004

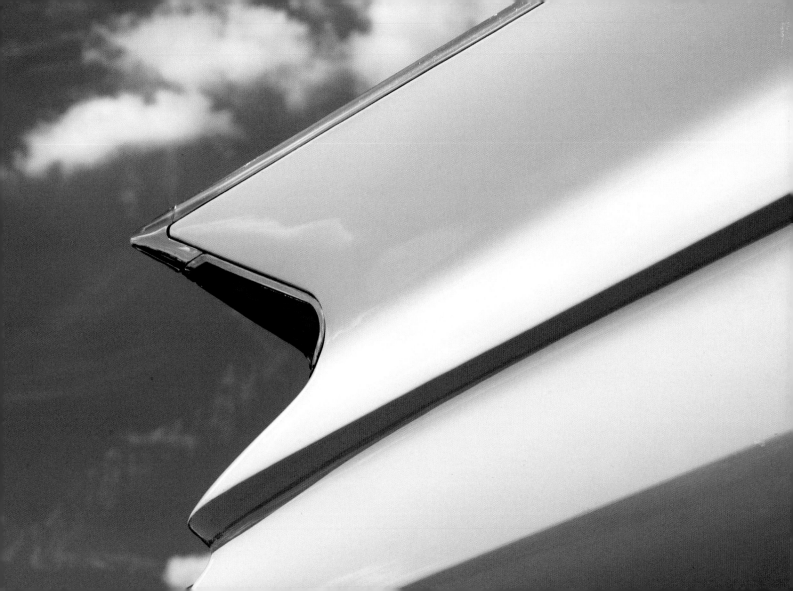

allowing more complex surface shapes, better aerodynamics, and faster prototype-to-production times. By the end of the decade, Japanese design was perfecting its own look and Chrysler, following a different path, reimagined icons of the past with extraordinary machines such as the Prowler, Viper, and the PT Cruiser.

Just as in the 1980s, when everyone knew the names of high profile "starchitects" such as Michael Graves and Richard Meier, these days many pop-culture cognoscenti (not just car fanatics) follow the careers of individual designers such as BMW's Chris Bangle and Ford's J. Mays as they hop from one firm to another. They have become celebrities, just as film directors and fashion designers have. And, just as pop music has splintered into countless micromarkets, so has the auto world evolved to fill every niche imaginable—custom and hot-rod nostalgia, performance-mad tuners, dragsters, drifters, baroque lowriders, pimped-out luxury SUVs, and big-wheeled "donks,"—all this without even mentioning the wild brand expansion of the industry's major players into "crossover" vehicles and "segment busters" targeted at every conceivable market.

Looking at Cars

Climbing into your car every day you are entering into a dialogue with its designers. Millions of dollars were spent, and every surface tailored to make you feel that this machine is perfectly suited for you, whether you are indulging in Dale Earnhardt NASCAR fantasies, enjoying some well-deserved luxury, or whisking your family safely and quietly to wherever. You know this. You are a sophisticated consumer. Nevertheless, these motorcars of ours are fraught with emotion and have their own powerful symbolic language.

When you wander along ranks of cars gathered for a cruise-in or a classic concours d'elegance, it's impossible to avoid the resemblance to an art gallery or museum. There is a century and more of history here, works of art on display, and everyone brings along their own preconceptions when judging automobiles, or architecture for that matter. But with the auto, personal style is most important. Styling has long been a dirty word in the field of design, but there is no escaping that autos are a powerful mode of self-expression for both designers and drivers. Whether it is the angle of an air scoop or the roar of the engine within that moves you, it is worth the effort to focus on the details, to look at them as their designers might.

The thirteen photo essays presented here, each one showcasing our photos of scores of classic models from all eras of automotive history, look at basic concepts in car design, such as line, symmetry, and color. They also concentrate on gritty mechanical components and on pure decoration for its own sake. Of course, the most fundamental detail of all is the wheel...

—Frank D. Sullivan and Fred Winkowski, 2008

Cadillac, 1961

17

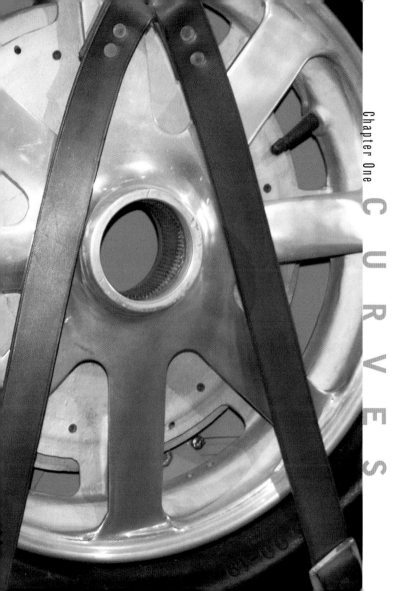

C
U
R
V
E
S

The wheel is the unchanging foundation upon which the auto is built. With its radiating spokes, it sets the theme for every design and is echoed by many other round elements, including the lights, steering gear, instruments, mirrors, and nameplates.

19

Bugatti. Type 35 Racing Wheel, 1924

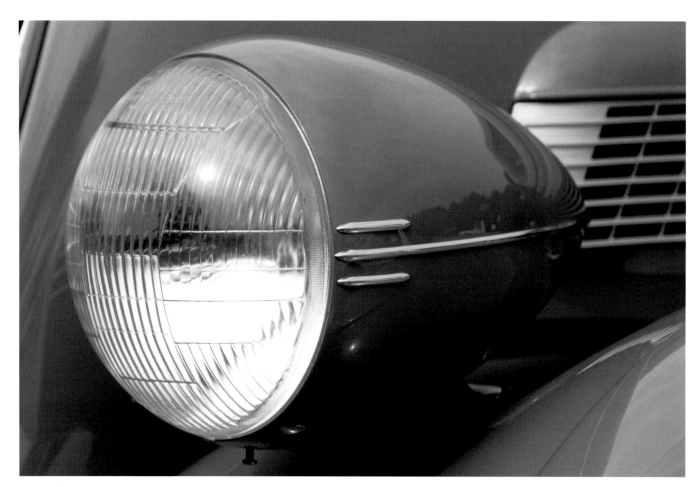

Nash, 1935

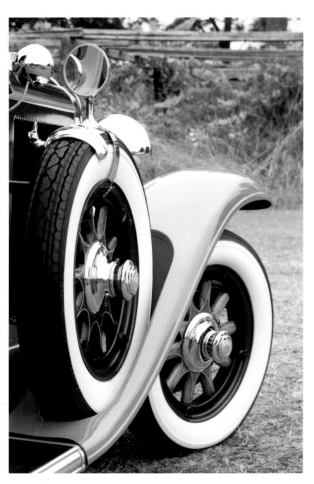

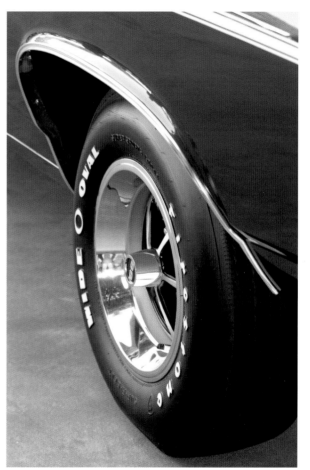

Buick, 1931

Camaro, 1960s

Sandford, 1927

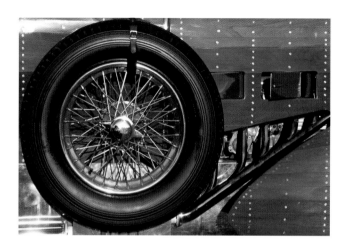
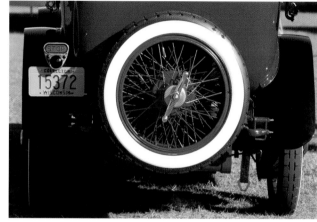
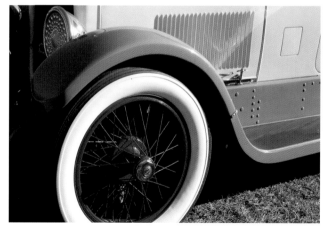

top, Lagonda, 1930s; bottom, Marmon, 1920s

top, Stutz, 1920s; bottom, Stutz, 1920s

24

Philson Falcon. 1959

Suzuki, GSX-R-4 Concept, 2004

Cadillac, Series 62, 1941

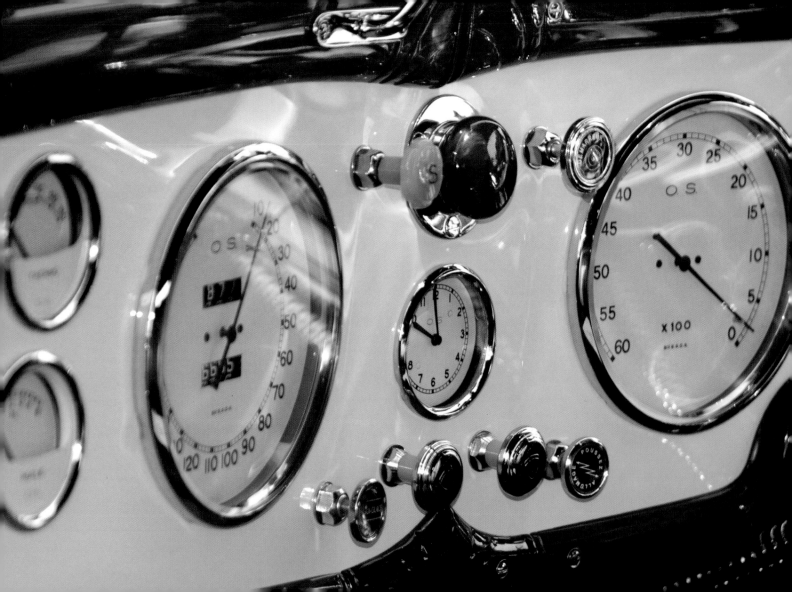

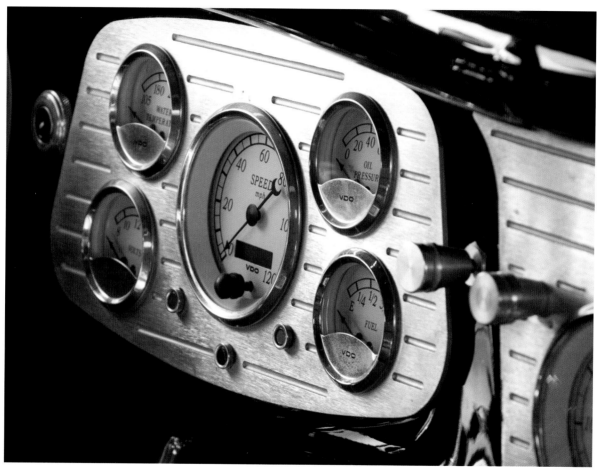

Ford, Custom Rod, 1930s; opposite, Darracq Talbot, 1938

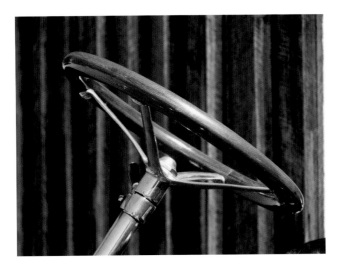

REO. 1907

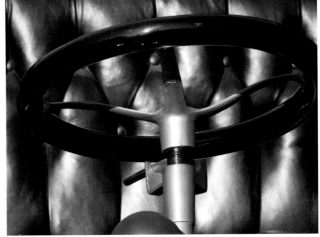

Cadillac, 1903

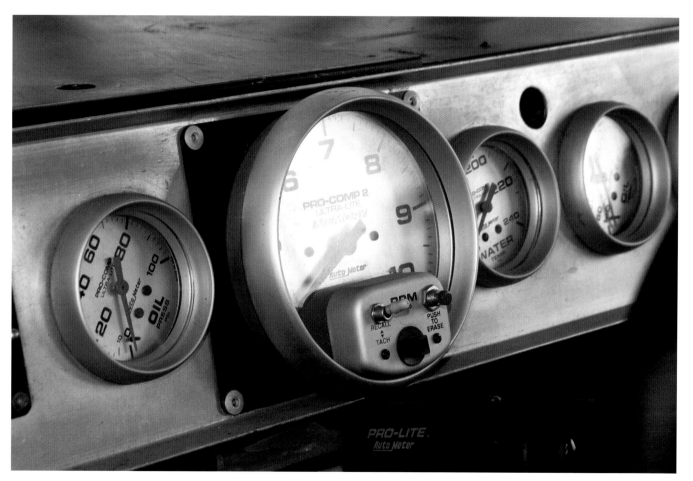

Chevrolet. Monte Carlo Modified, 1996

Dodge, 1923

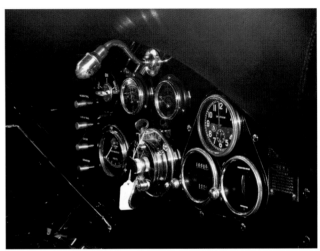

Locomobile, Berline, 1914

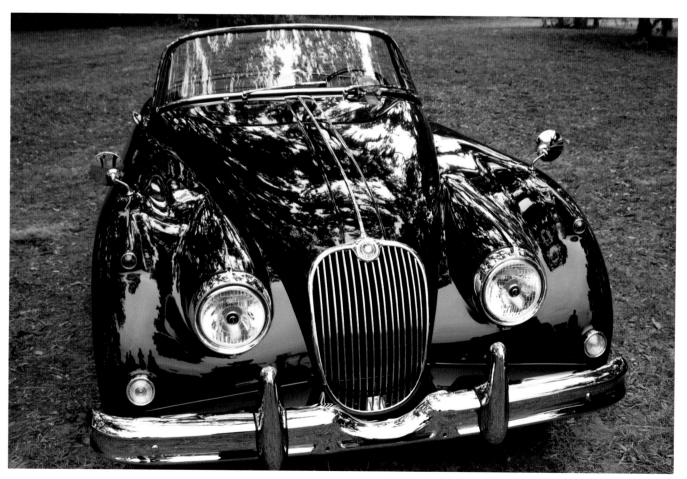

Jaguar XK-150, 1960

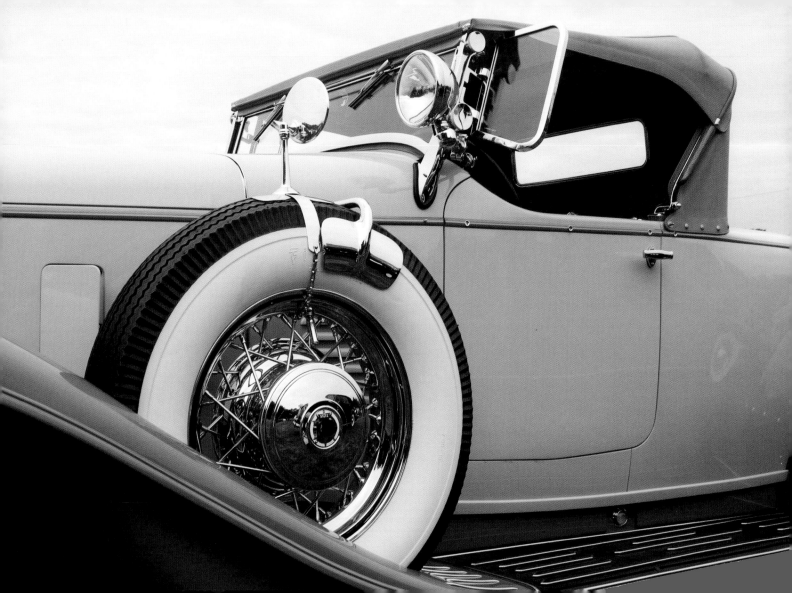

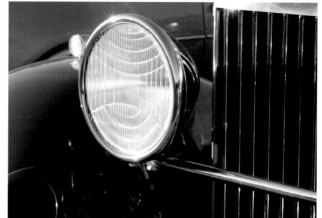

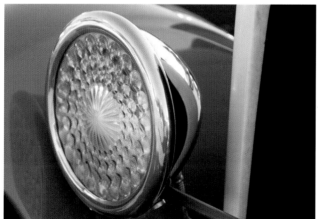

top, Bugatti, T-57C, 1936; bottom, Headlight, 1920s
opposite, Stutz, DV32 Roadster, 1933

top, Rolls Royce Phantom II, 1920s; bottom, Plymouth, Racer, 1930s

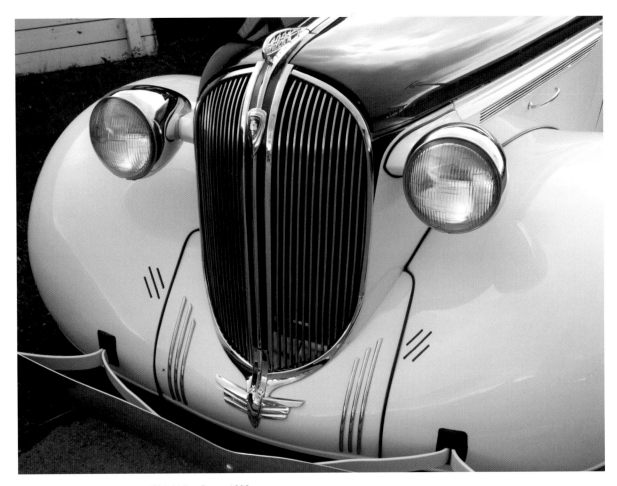

34

Plymouth, 1938; opposite, Jaguar/SS1, Airline Coupe, 1935

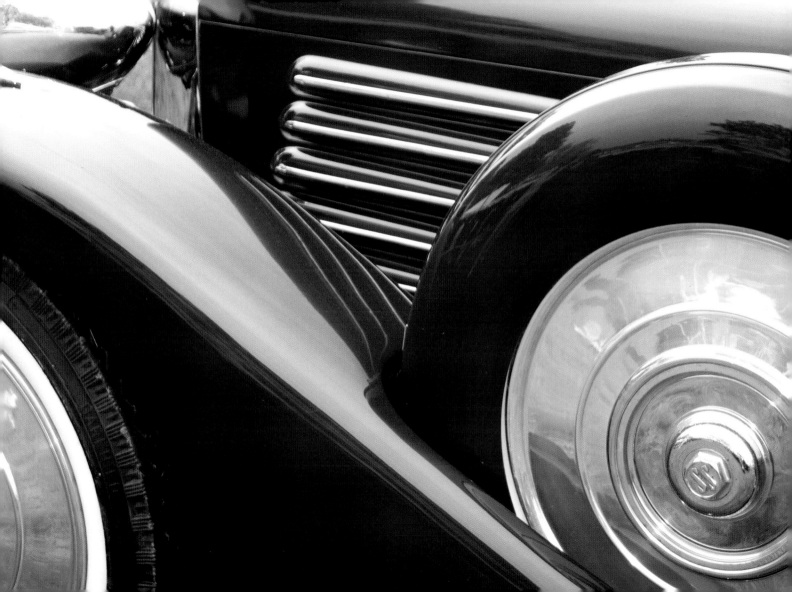

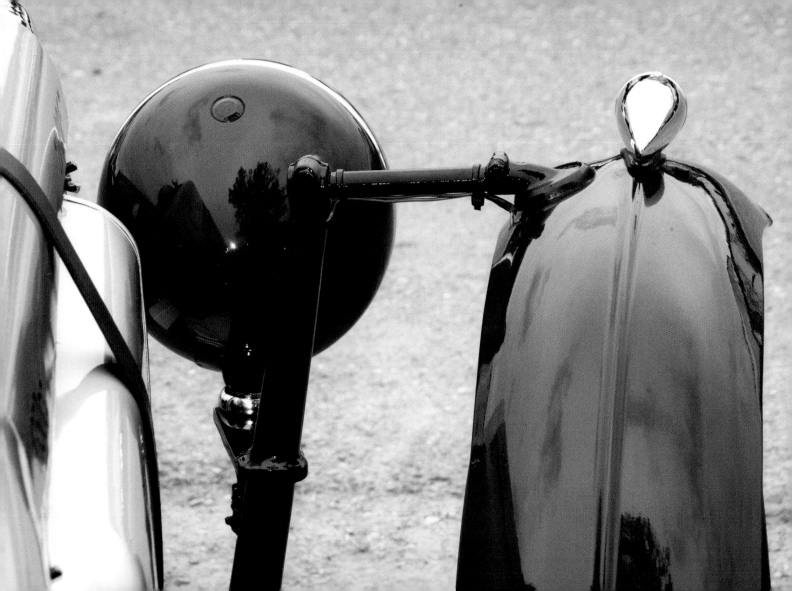

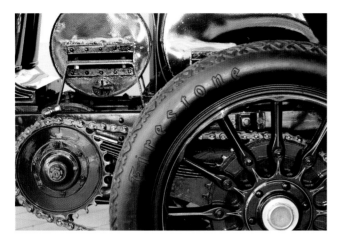

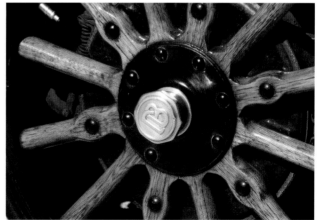

top: Simplex, 1908; bottom, Ford, Model A, 1930; opposite, MGBT, Special, 1939

top. Stutz, Bearcat, 1931; bottom, Dodge, 1923

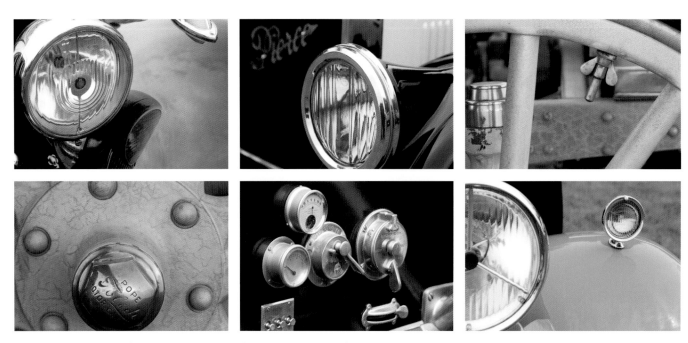

top row: Jaguar/SS1, Airline Coupe, 1935; Pierce Arrow, 1925; Pope Toledo, Racer, 1904; bottom row: Pope Toledo, 1904; Garford Six-Fifty 6-14, 1912; Cadillac V-16, 1931

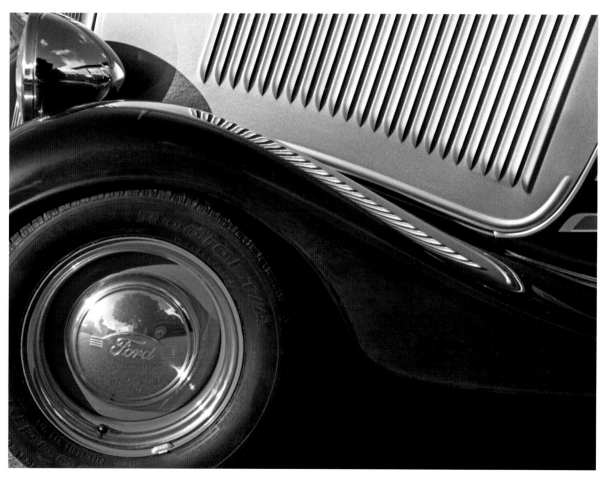

Ford Model A, 1934

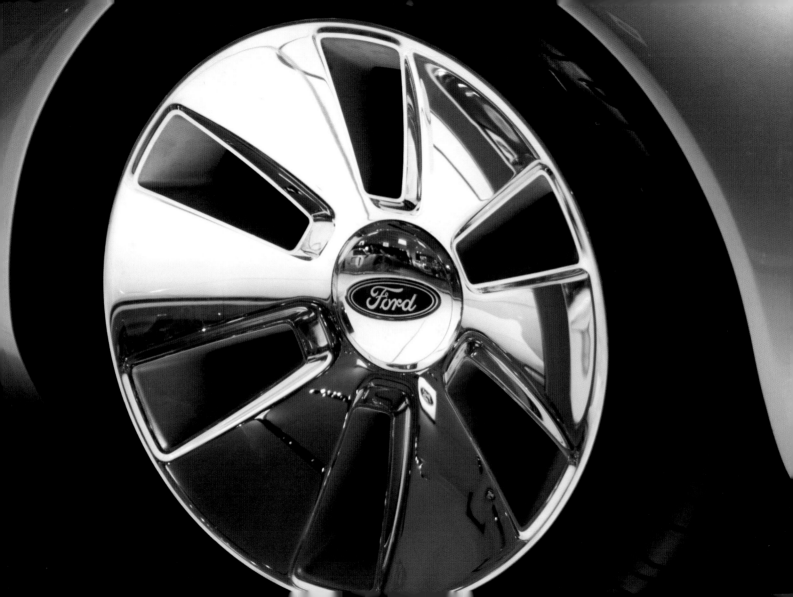

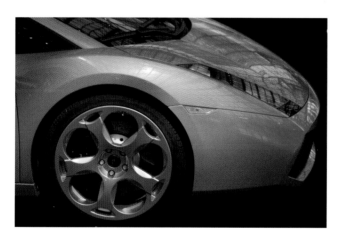

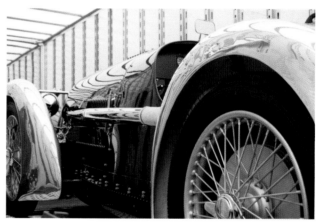

Lamborghini, Gallardo, 2004; opposite, Ford Reflex Concept, 2006.

Unidentified Racer, seen at Lime Rock, CT

L I N E S

Lines, straight or curved, sweep through space
to form surfaces and solid contours, and repeat
to form endless patterns. The material of choice
is sheet metal, either steel or aluminum, because
it is malleable and easily shaped for mass
production. The static, heavy shapes of early
machines have gradually evolved into dynamic,
muscular, and streamlined outlines.

43

Ford, Deluxe Coupe, 1939

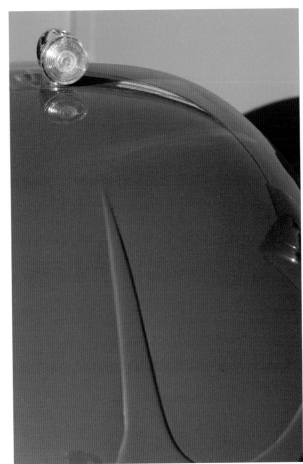

44

Rolls Royce Phantom II, 1930s

Stutz Boattail, 1927

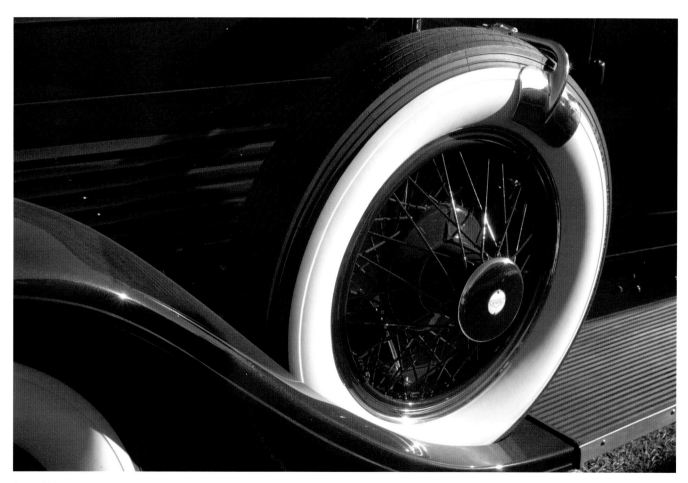

Stutz, 1920s

BMW, 328, 1936; opposite. Studebaker, Commander, 1931

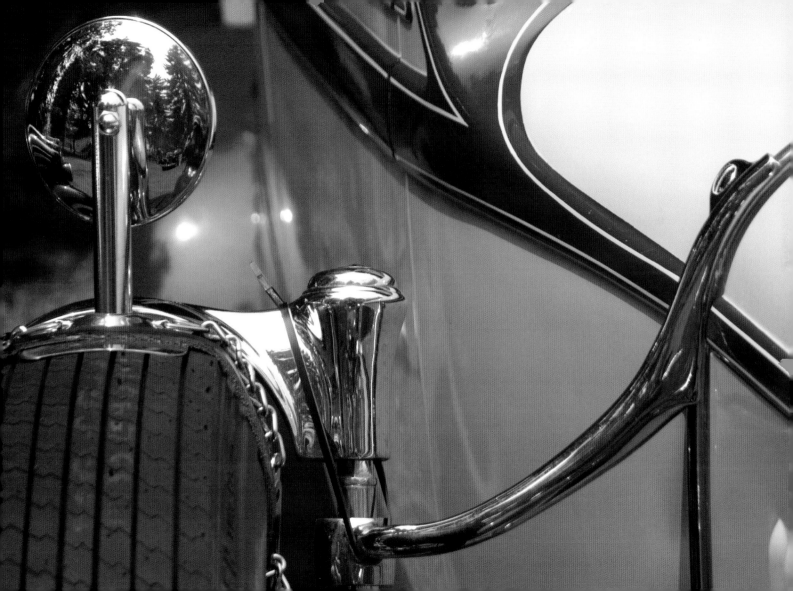

1976 Cadillac with 1959 fin

Delahaye, 135M, 1937

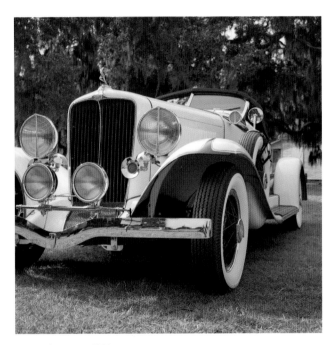

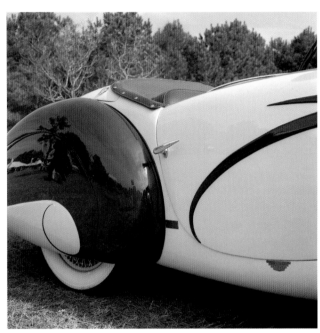

Auburn, Speedster, 1932 Delahaye, 135M, 1937

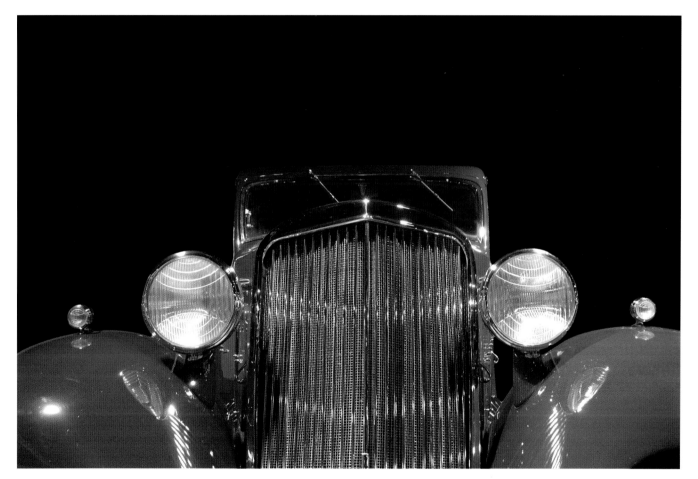

Franklin, Club Brougham, 1932

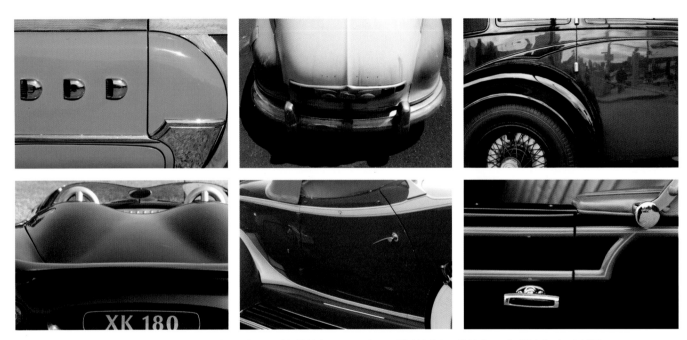

top row: Packard, "Woody," 1951; Nash, 1950; Rolls Royce, Phantom III, 1938; bottom row: Jaguar XK-180; Auburn V-12, Boattail, 1933; Packard, 1929

Lotus Racer, 1960s

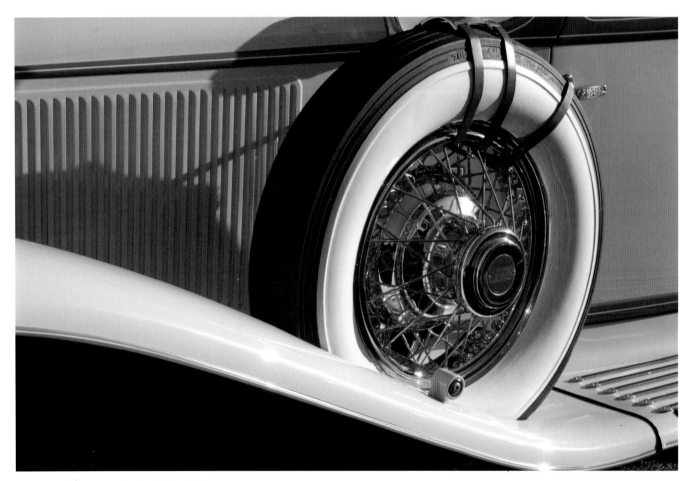

54

Cord L29, 1929; opposite, Chrysler, Airflow, 1935

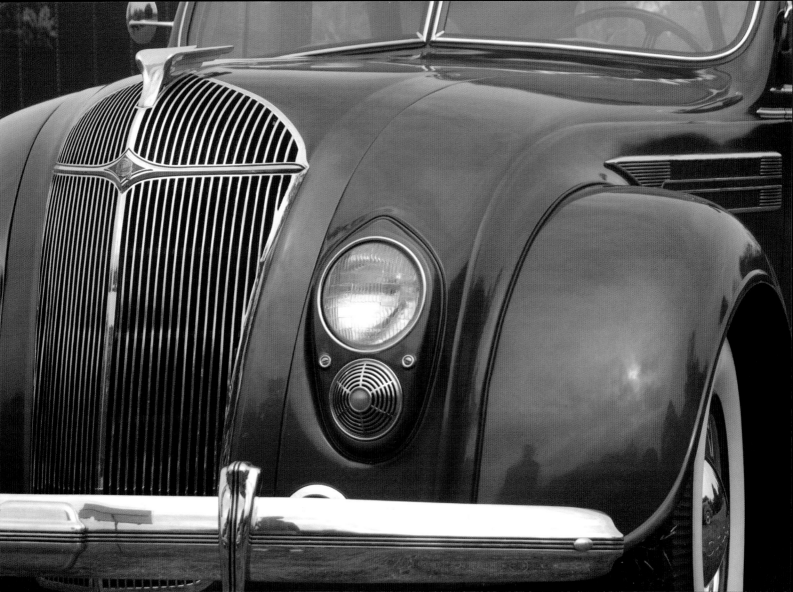

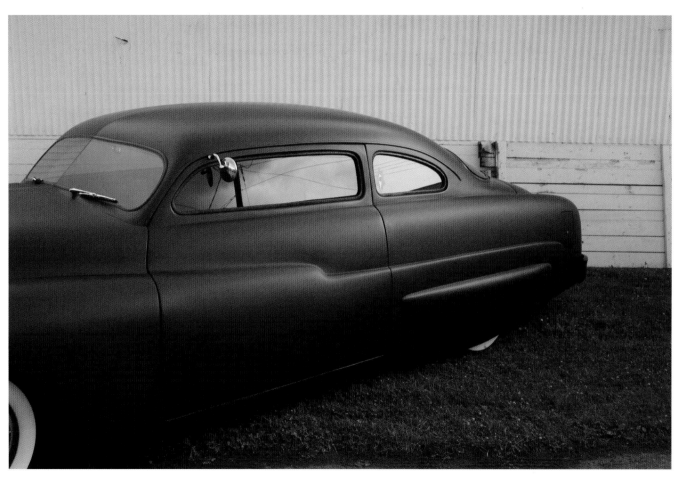

Mercury, 1951

top, Darracq Talbot, 1938; bottom, BMW, 328, 1937

top, Mercedes 540K, 1938; bottom, Ford, Model A, 1930

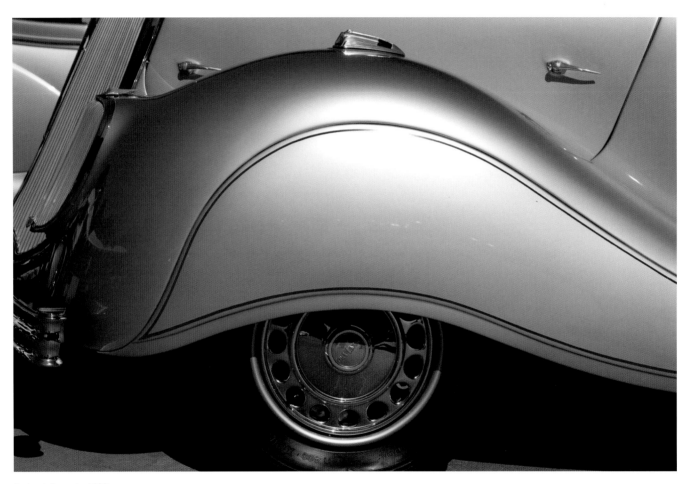

Panhard, Dynamic, 1938

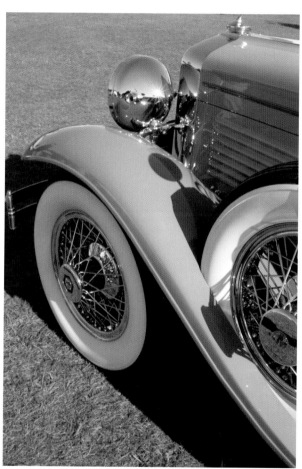

Stutz Blackhawk, 1930s

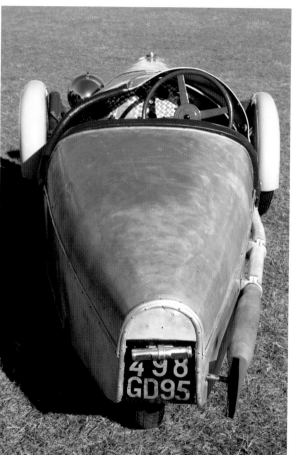

Stanford, 1927

Darracq/Talbot, Lago T-150C, 1938

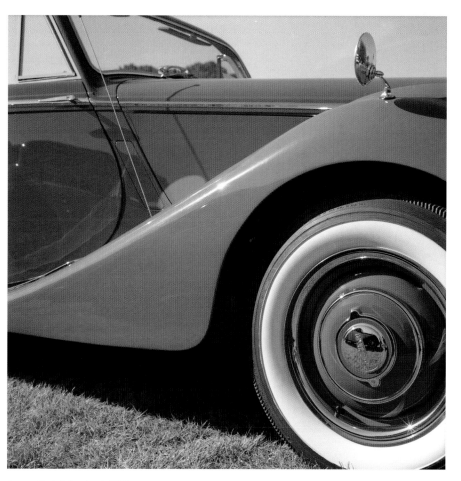

Jaguar, Mark V Drophead, 1950

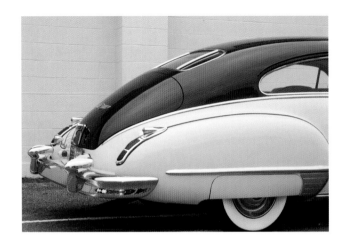

top, Cadillac, Series 62 Club Coupe, 1941; bottom, Studebaker, Avanti, 1963 Daniels, 1921; opposite, Cooper Monaco, 1960

Kaiser Darrin, 1954

Pontiac, Solstice, 2006

Mustang, 2000s

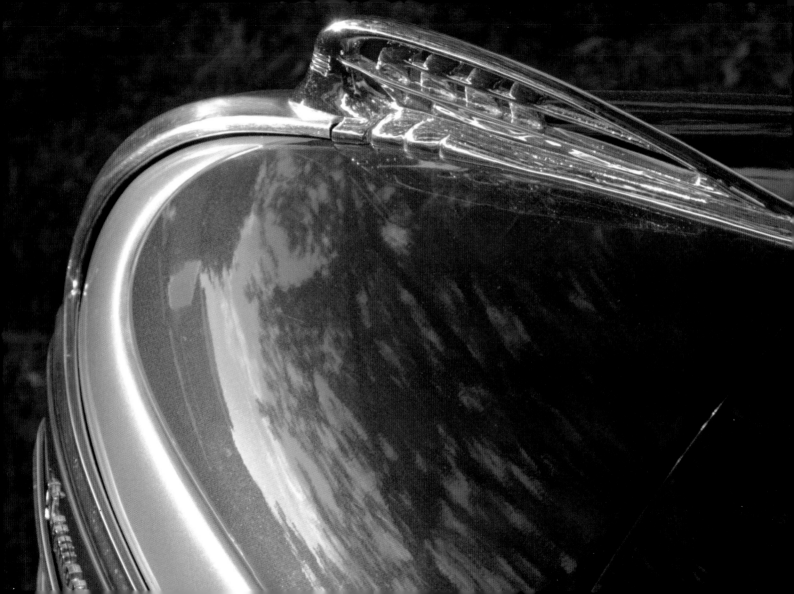

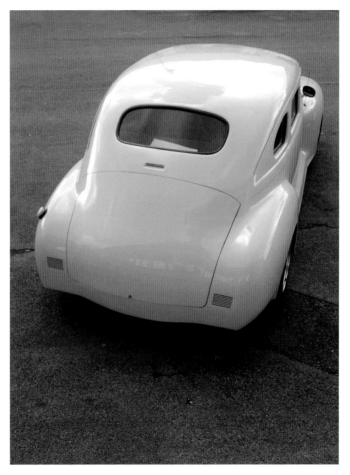

Plymouth, 1946; opposite, Plymouth, 1939

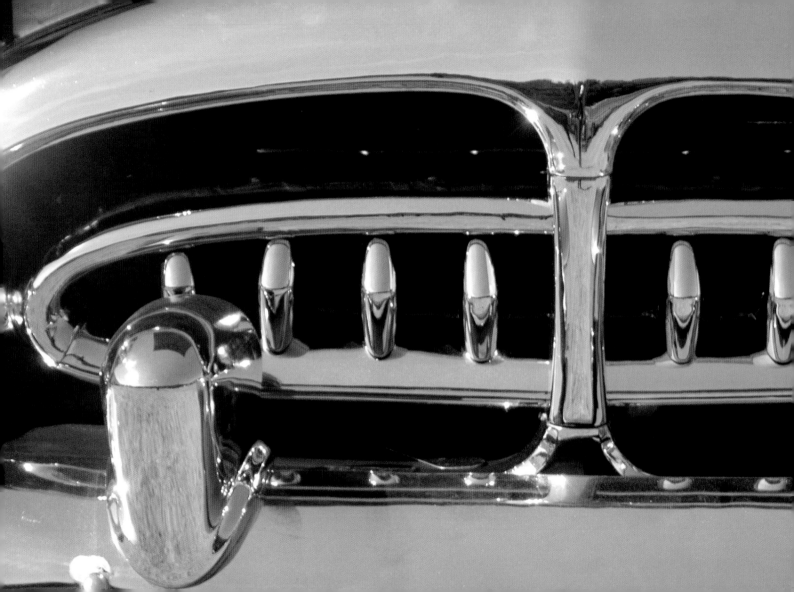

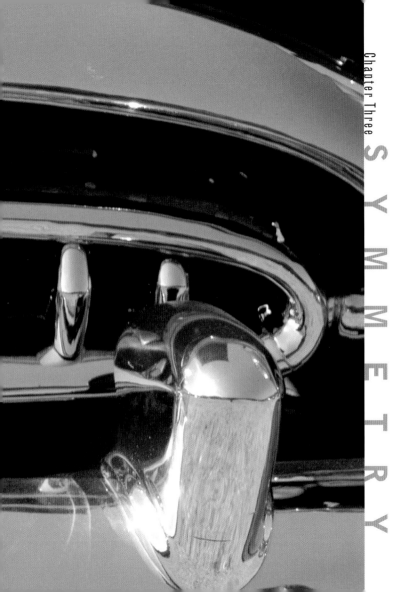

SYMMETRY

All moving things need balance and equilibrium.
From front, rear, and above, the car shows
almost without exception, a perfect mirror
symmetry, one of the simplest measures of
organic beauty.

Packard. 1951

69

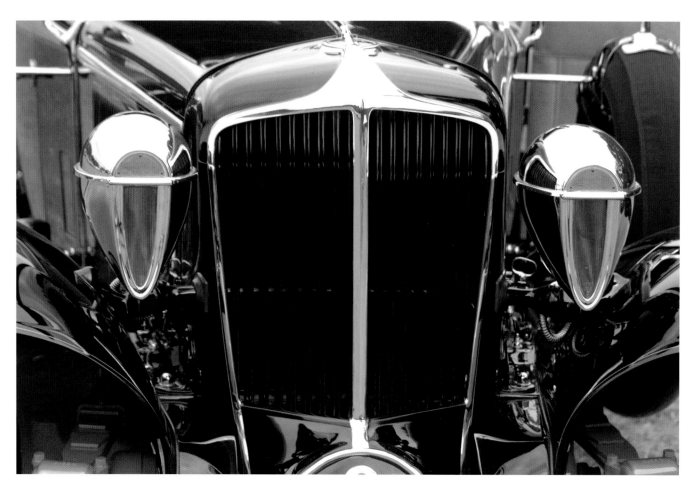

70

Cord L29, 1929

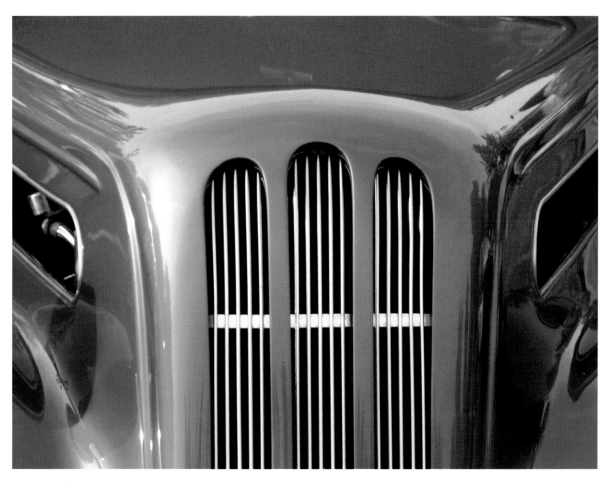

Ford Anglia, 1948

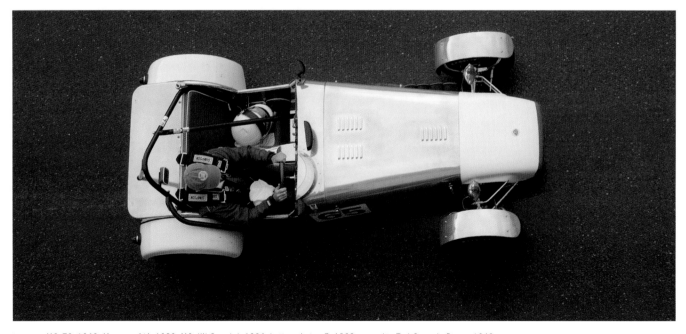

top row: MG, TC, 1949; Morgan, 4/4, 1959; MG, KN Special, 1934; bottom, Lotus 7, 1965; opposite, Tad Segar's Racer, 1940s

Chevrolet, Nomad, 1955

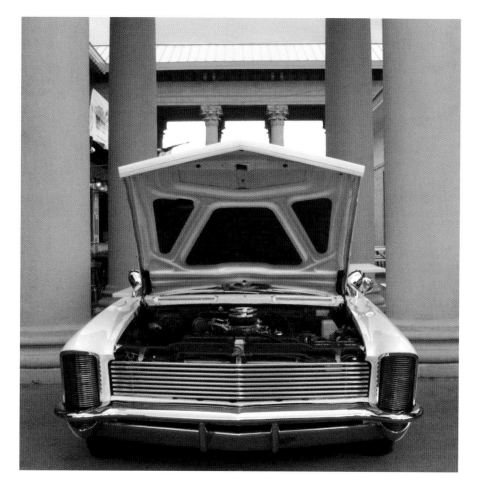

Buick, Riviera, 1965

76

Nash, 1935

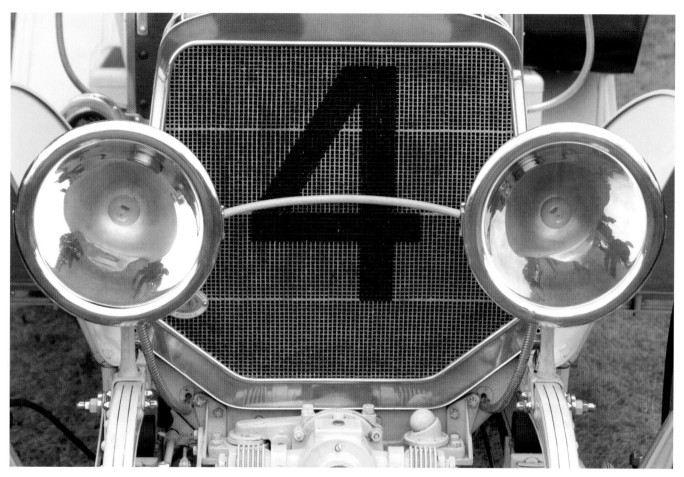

Lozier, 1913

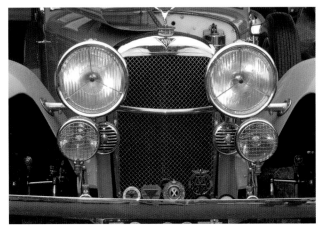
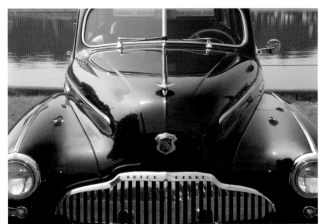

78

top, Ford, Station Wagon, 1946; bottom, Alvis, Speed, 1930s

top, Studebaker, 1934; bottom, Buick, 1942

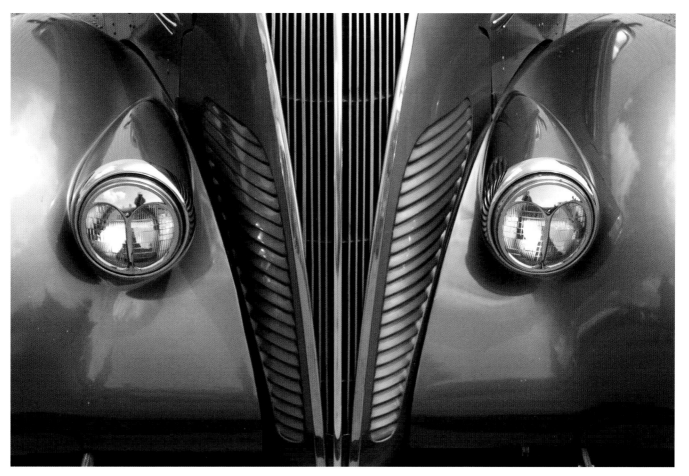

Terraplane, 1937

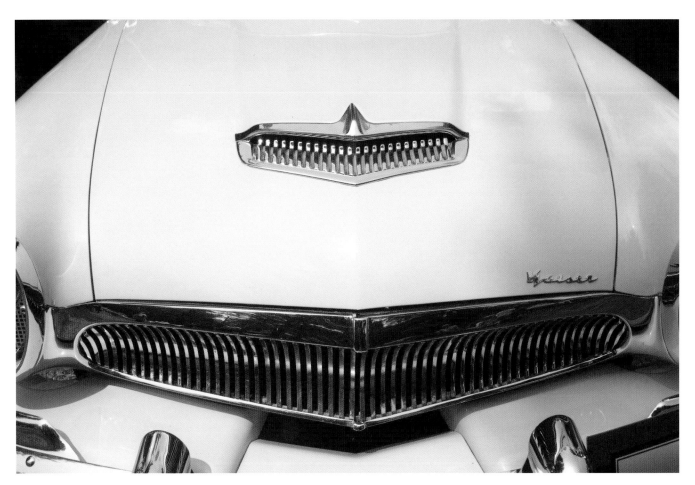

Kaiser, Manhattan, 1954

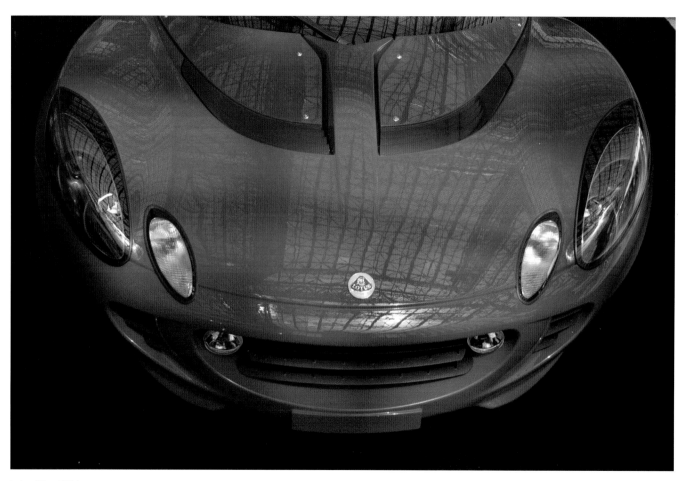

Lotus. Elise, 2005

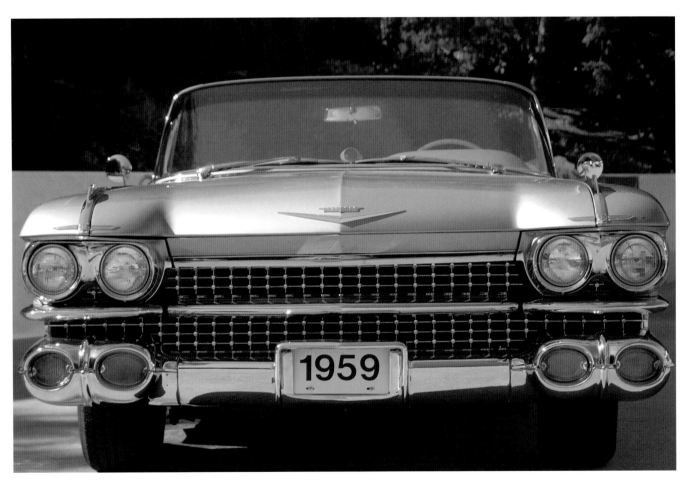

Cadillac, 1959

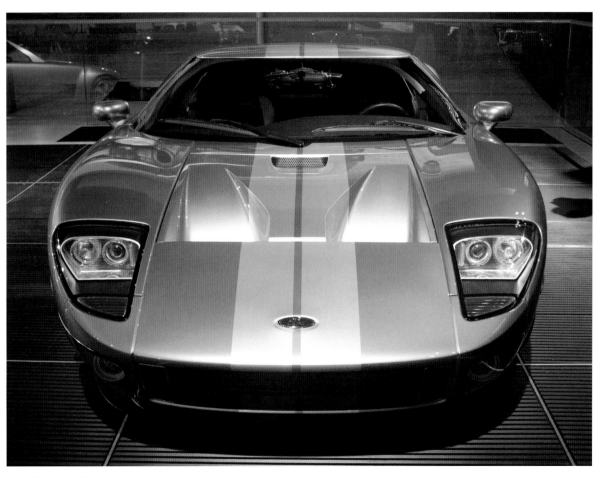

Ford. GT Concept, 2004

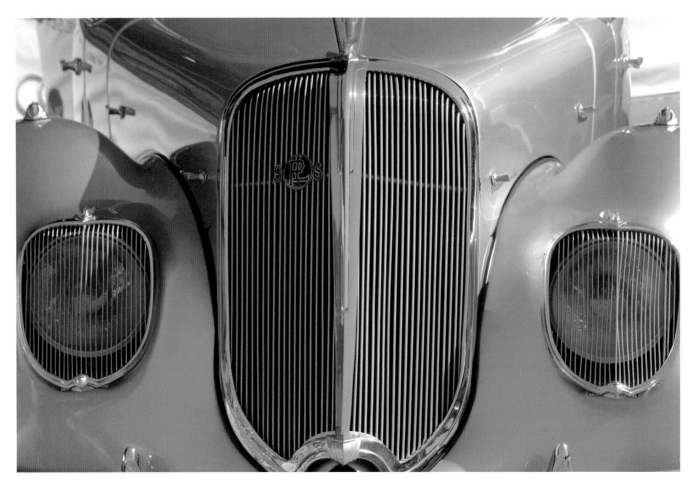

Panhard, 1938

Porsche 1500, 1953

Cadillac V-16, 1938

Chrysler, New House. 1931; opposite. Ford Custom, 1930s

REFLECTIONS

Glossy surfaces have long been required as part of an automobile's finish. By studying reflections and highlights in flat planes or smooth curves, designers take the measure of a polished surface's "rightness," painstakingly refining each panel to eliminate jarring kinks or unsightly transitions. Many coats of lacquer, lovingly buffed, give a "yard-deep" finish and visually shave pounds from the heavy sheet metal.

Ford, 1937

89

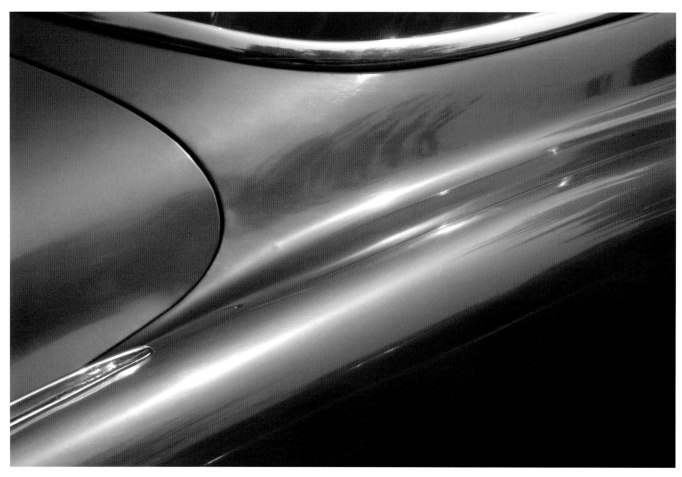

Chevrolet, Deluxe, 1951

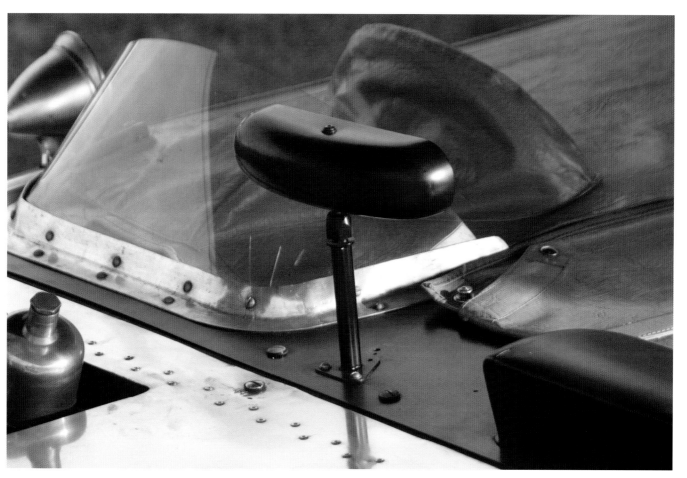

Philson-Falcon, 1959

92

Chevrolet, Low Rider, 1971

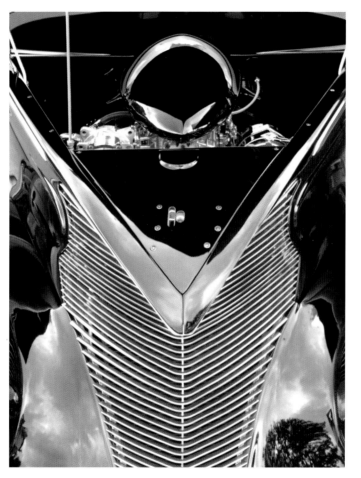

Ford, Hot Rod, 1930s

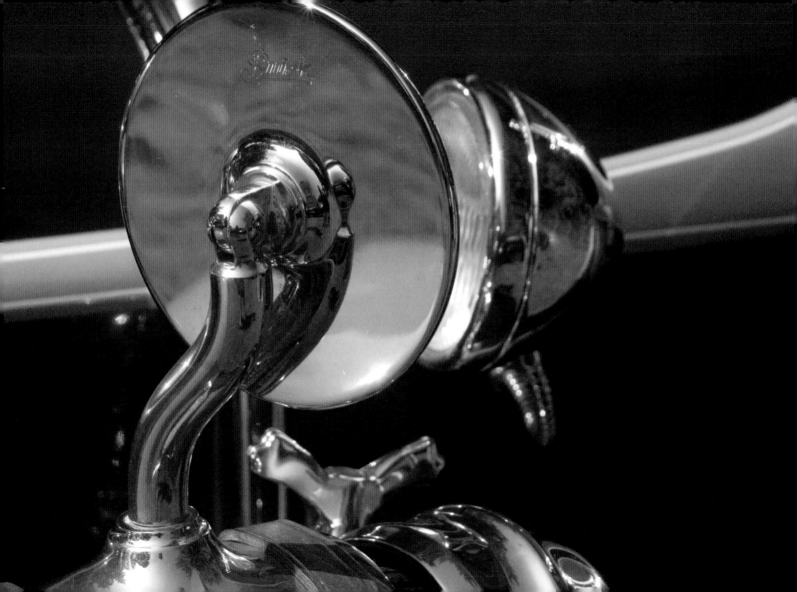

Studebaker. Hawk. 1962; opposite, Buick. 1931

Ford Custom. 1933

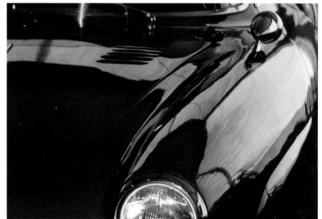

Jaguar, Mk V, 1950

top, Anglia, 1948; bottom, Alfa Romeo, Giulietta, 1963; opposite,
Ford. Reflected in Cadillac, 1949

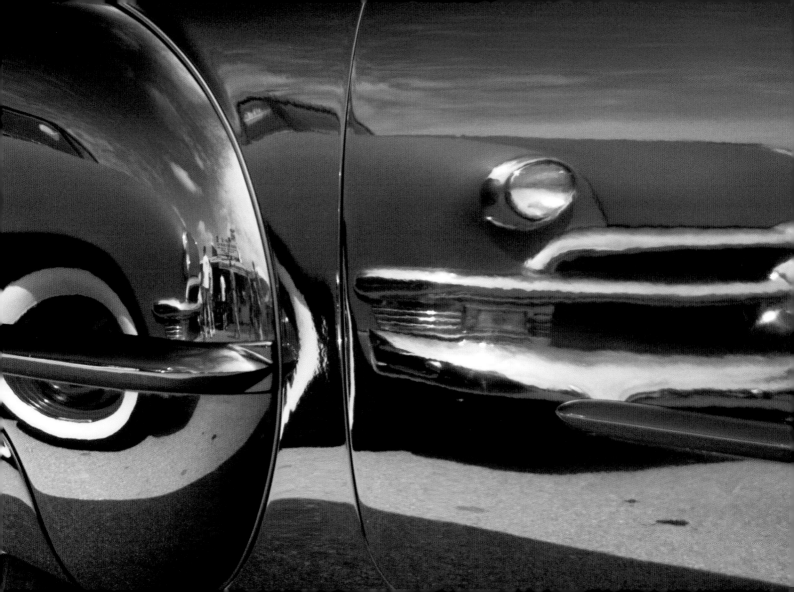

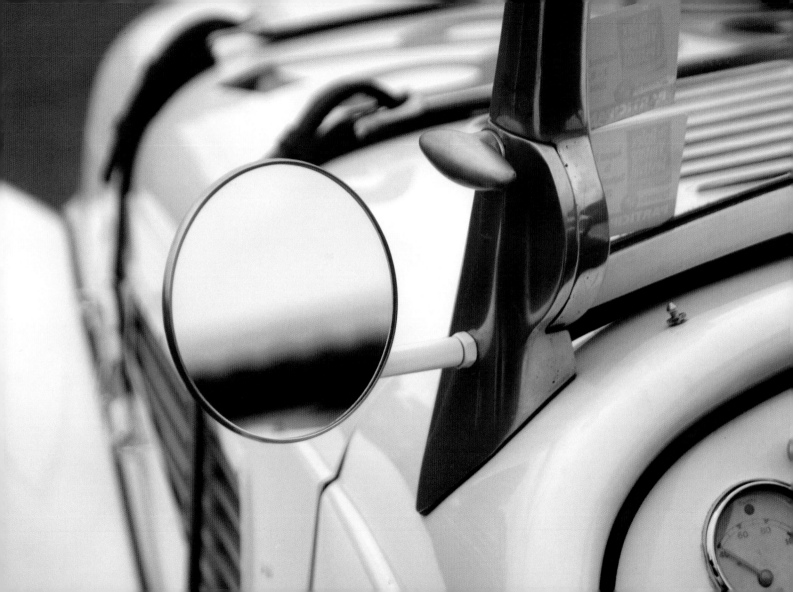

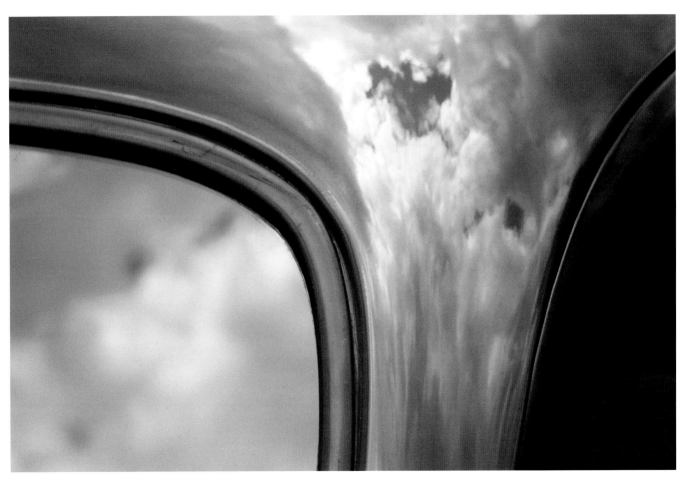

Plymouth, 1938; opposite, BMW, 328, 1936

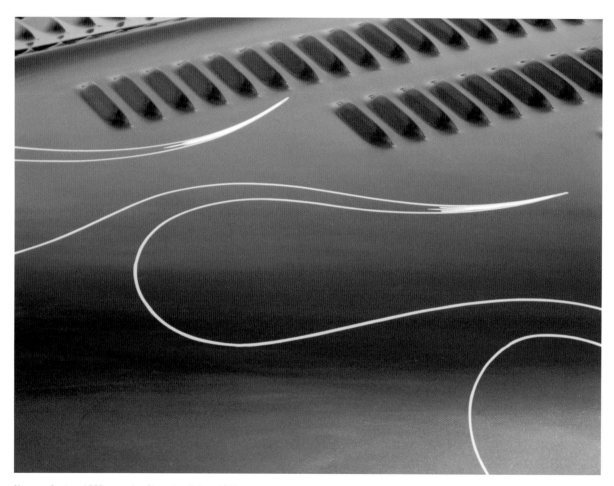

Mercury, Custom, 1950; opposite, Chevrolet, Deluxe, 1951

top, Packard, 1941; bottom, Stutz, 1920

top, Chevrolet, 1940; bottom, Lincoln, 1924;

Chevrolet, Low Rider, 1971

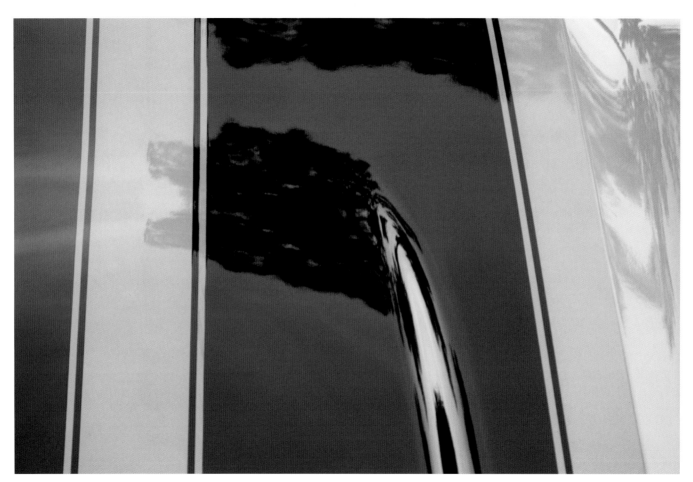

Chevelle, 1970s

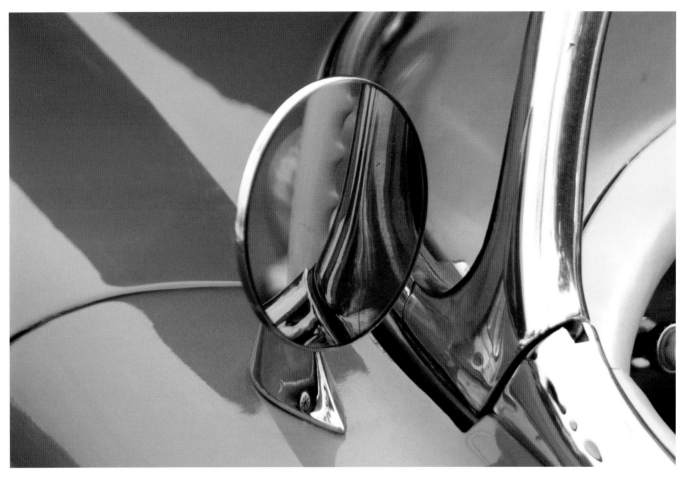

Chevrolet, Corvette, 1954

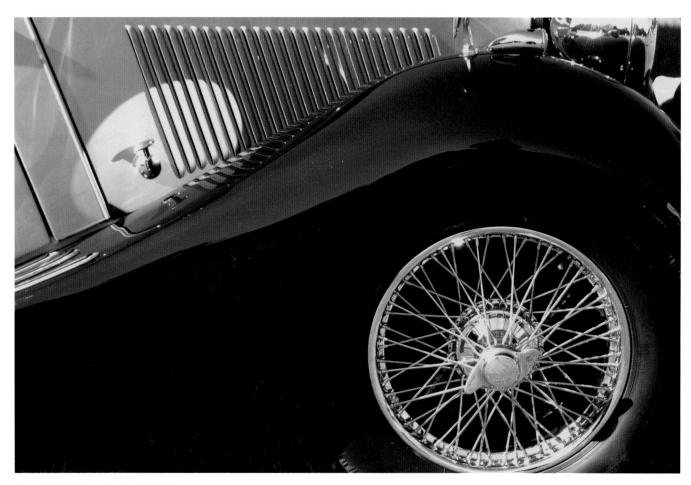

Jaguar, SS, 1948; opposite, Buick, 1938

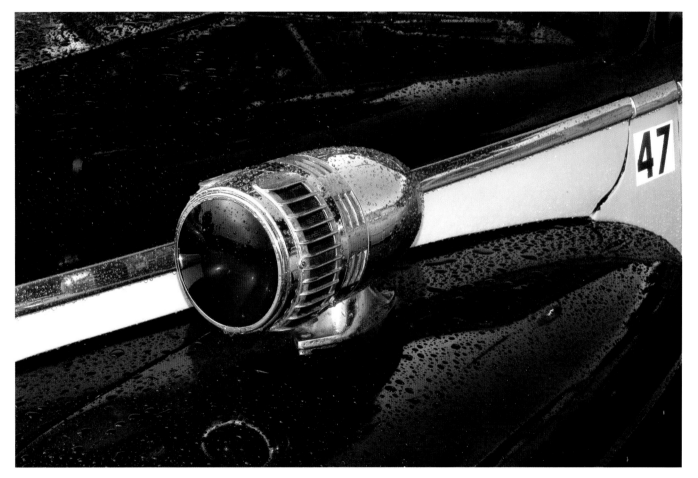

Ford, Police Car, 1947; opposite, Ford, Thunderbird, 1962

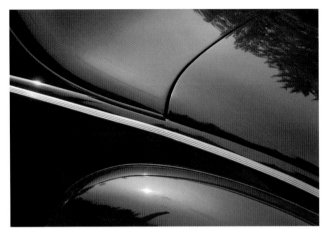
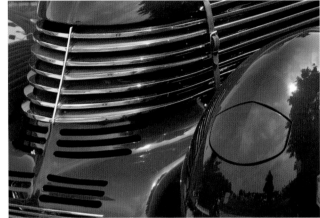

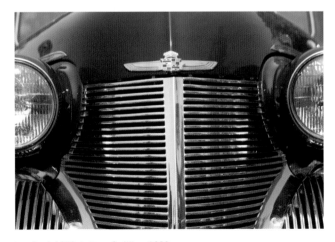
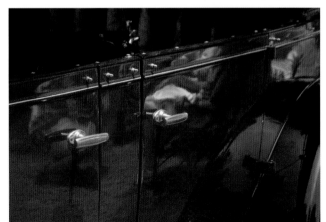

top, Ford, 1940; bottom, Cadillac, 1939

top, Kurtis, Custom, 1937; bottom, Packard, 1926

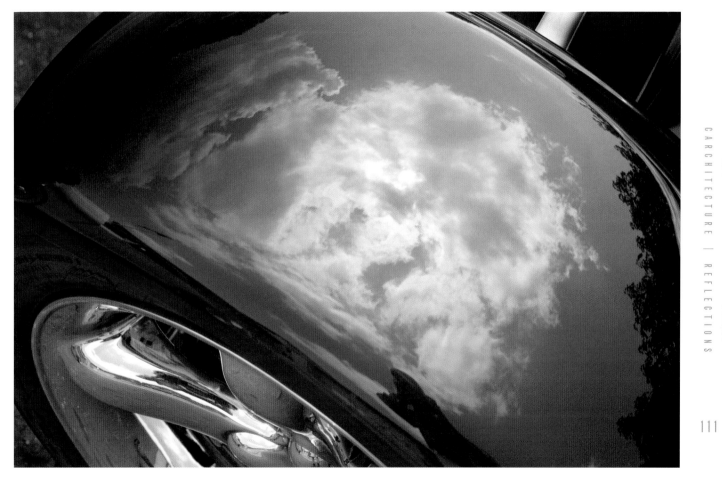

Plymouth, Prowler, 2001

Ford, Custom, 1951

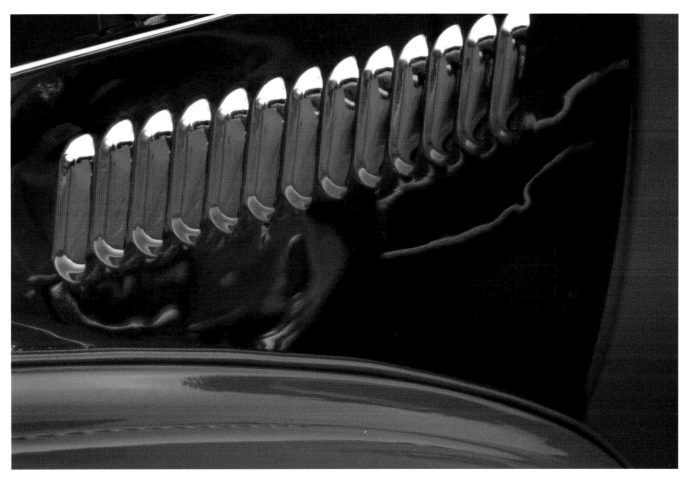

Ford, Roadster, 1932

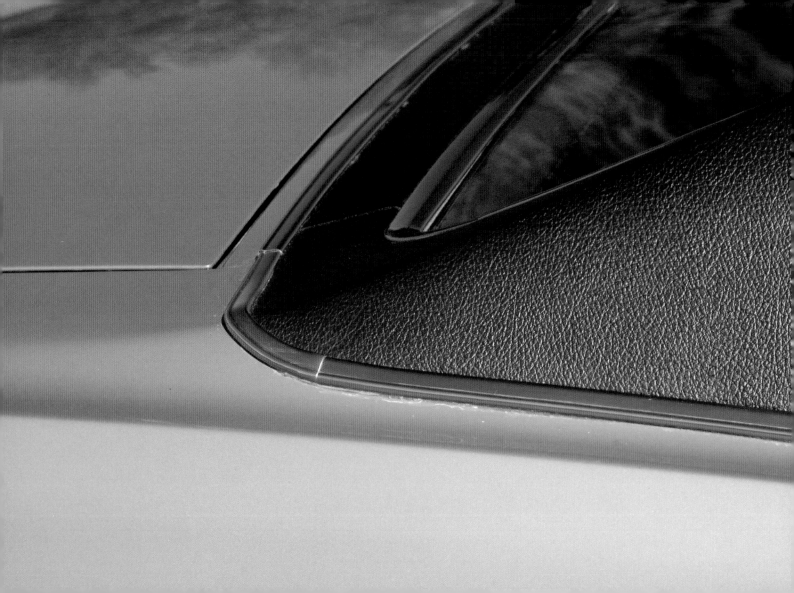

TRANSPARENCY

Glass was an early addition to the designer's toolkit as shield from the wind. Simple flat planes evolved through the most complex of curves to meet the demands of streamlining. The modern car's window area, known as "the greenhouse," enables the driver not only to see out, but also allows the bystander a glimpse into the car's secret interior.

Chevrolet, Monte Carlo, 1972

Lotus, XI, 1957; opposite, BMW, 1971

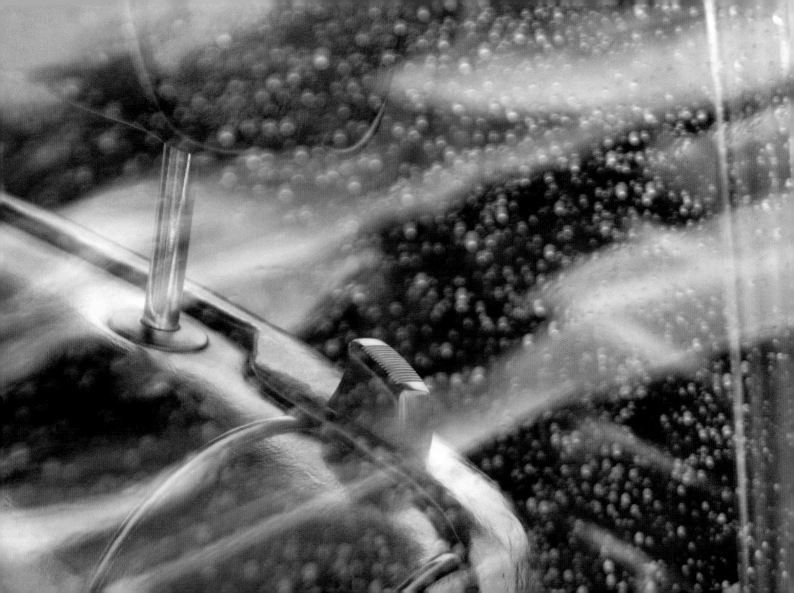

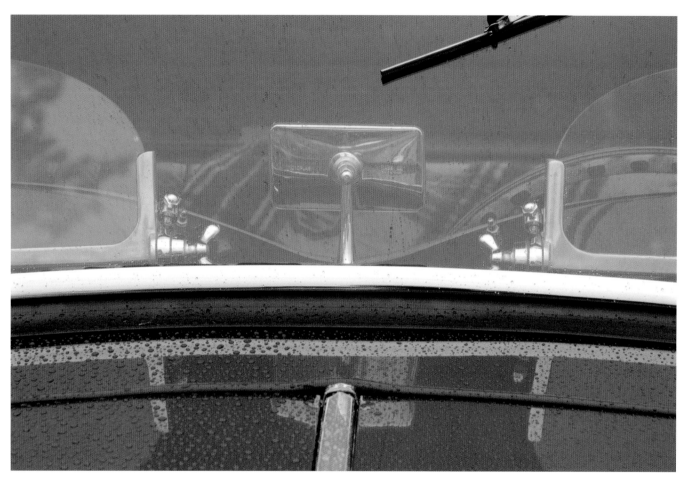

118

MG, TD, 1953

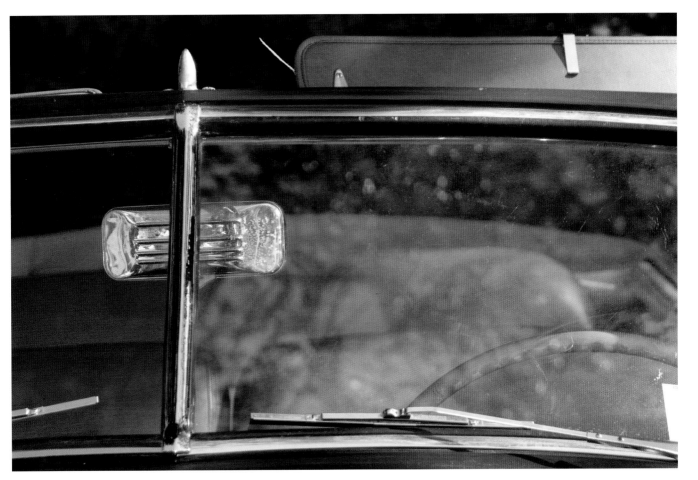

Packard, 1948

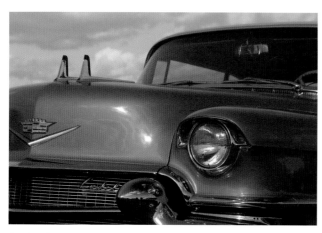

Cadillac Eldorado Seville, 1956

Ford, Model A, 1930

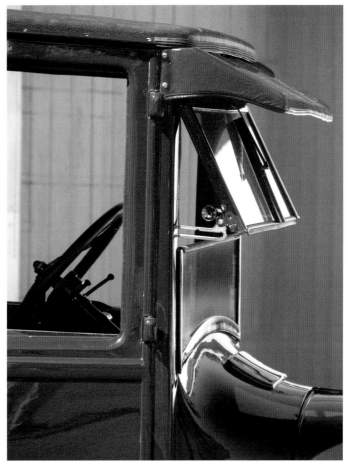

Ford. Model T. 1927

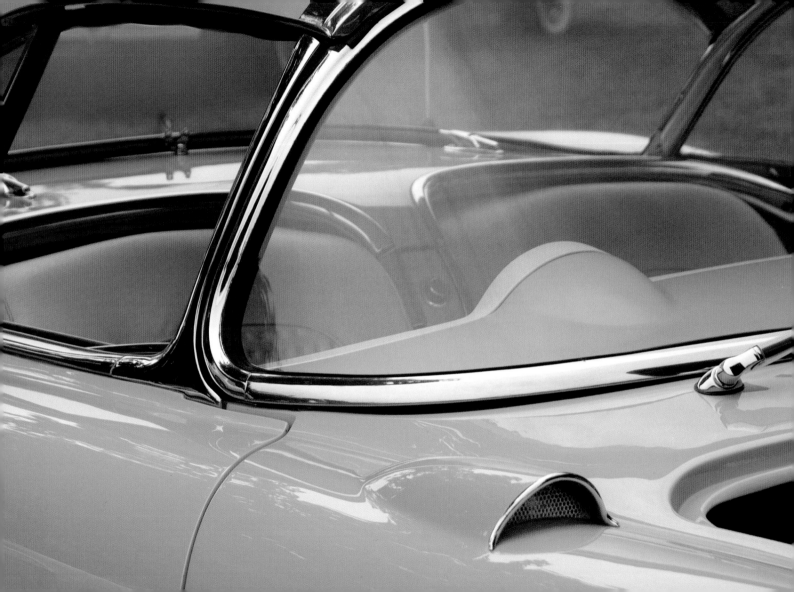

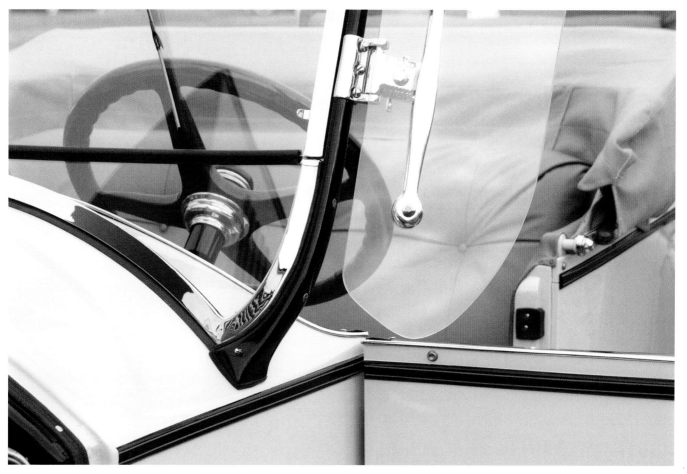

Pierce Arrow, 80, 1925; opposite, Chevrolet, Corvette, 1957

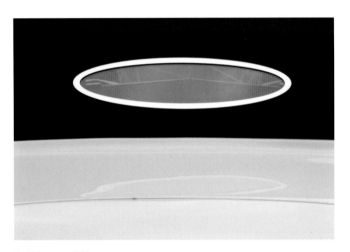

Ford. Custom, 1930s

Chrysler Imperial, 1931; opposite, Chevrolet, 1960

Ferrari, 512S, 1969

Bentley, Speed 8 Racer, 2003

Mazda, Miata, 2004; opposite, Audi, S4, 2002

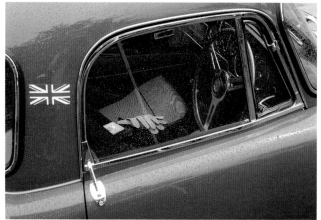

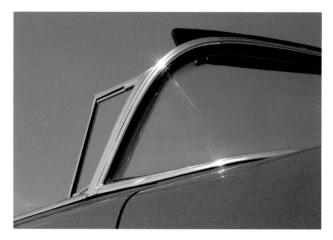

top, Chevrolet, Chevelle SS396, 1968; bottom, Cadillac, 1958

top, MGA, Sebring, 1961; bottom, Hudson, 1913

Ford, 1937

Pontiac, 2001

Saleen, S7, 2004

L I G H T S

Night travel requires light. Car were first
lit with antiquated carriage lamps, which
glowed dimly with kerosene or acetylene.
The streamlined parabolic shape of electric
headlights then became the standard for more
than thirty years. Today, there are many new
organic forms, including halogen, xenon, and
LEDs that light up white or blue to the car's
front and red and amber to its rear.

135

Chrysler, New Yorker, 1956

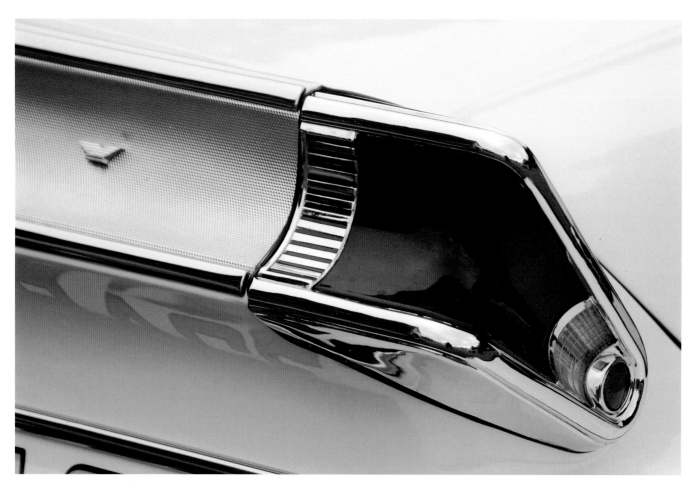

Mercury, Turnpike Cruiser, 1957

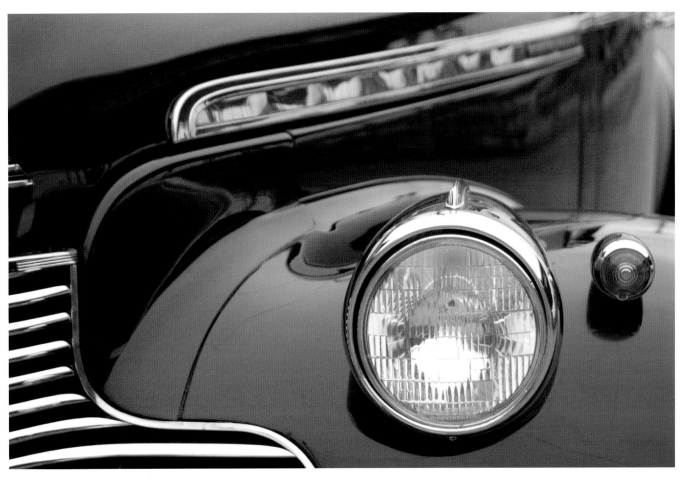

Chevrolet, 1940

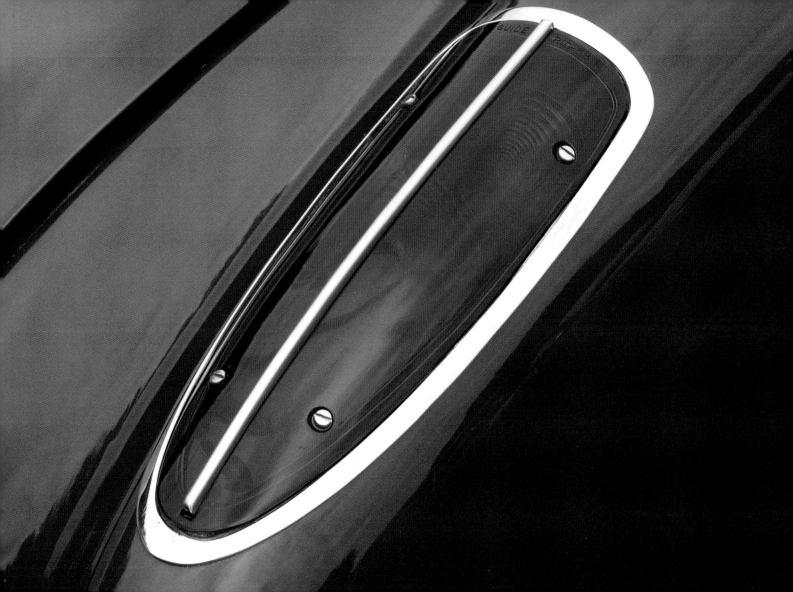

Kaiser Darrin, 1954; opposite. Corvette, 1959

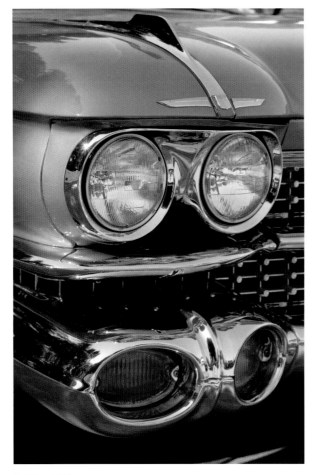

Cadillac, 1959

Studebaker, 1952; opposite, Plymouth, Hemi, 1970

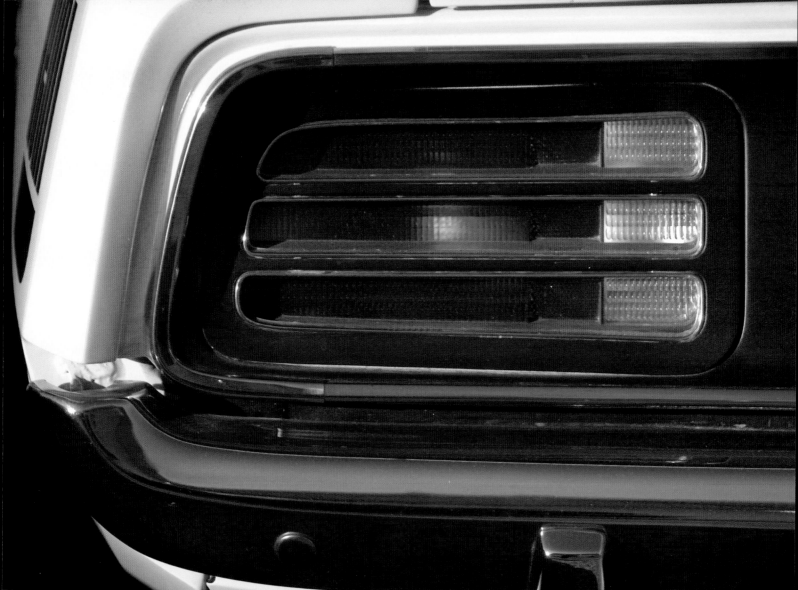

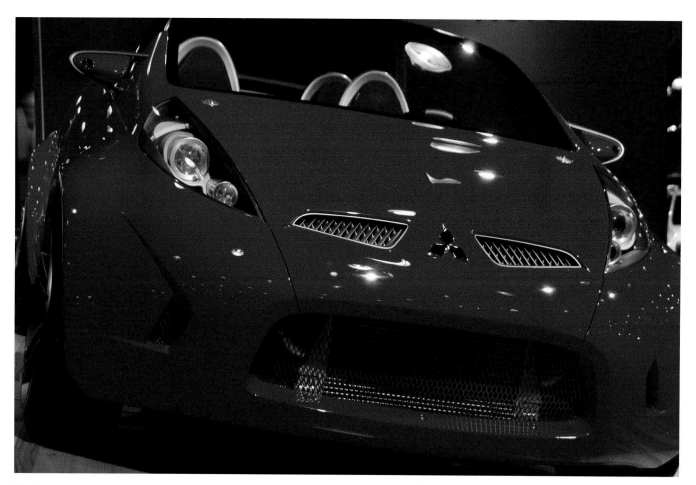

142

Mitsubishi Eclipse Spyder, 2004

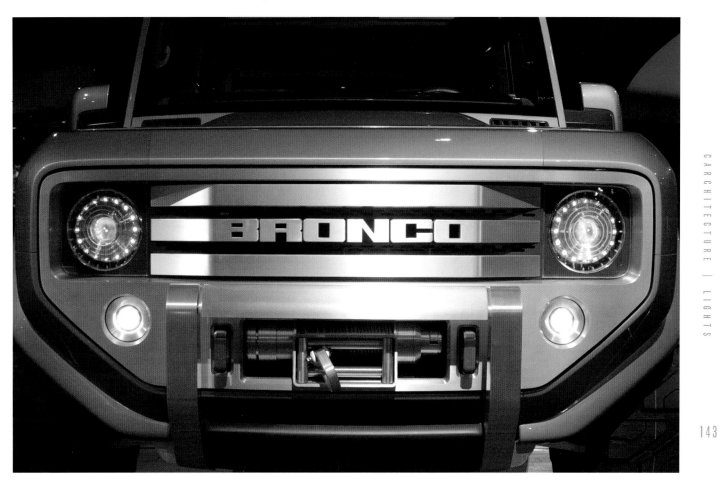

Ford, Bronco Concept, 2004

144

Plymouth, Road Runner, 1969

Dodge, 1970s

top, BMW, 327, 1937; bottom, Chrysler, 300, 1955

top, Chevelle, SS, 1969; bottom, Packard, 1940; opposite, Stutz, 1929

Ford, 1957; opposite, Chrysler, 1961

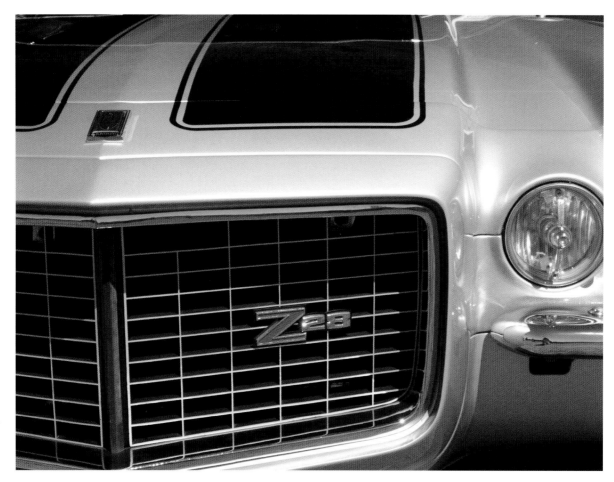

Camaro, Z-28, 1973

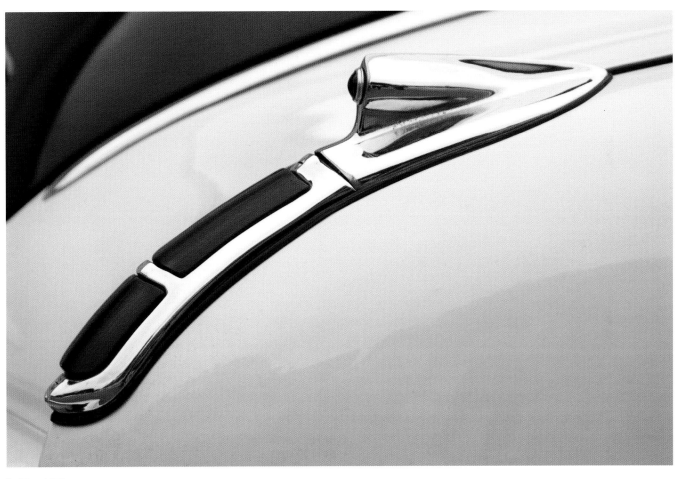

Cadillac, 1947

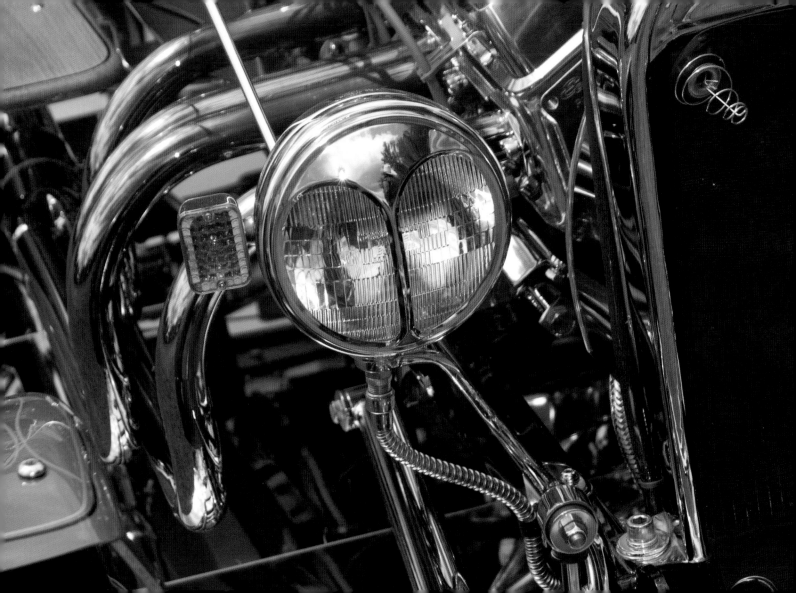

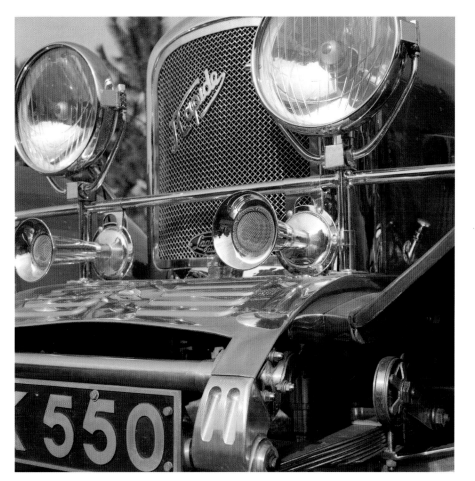

Lagonda, Rapide, 1939: opposite, Ford, Model T Hot Rod, 1920s

154

Cord, L 29, 1929

Lincoln, 1924

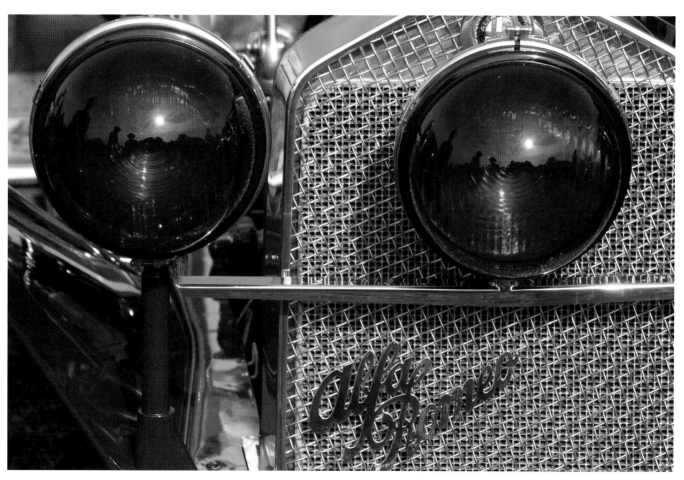

Alfa Romeo, 6C 1750, 1929

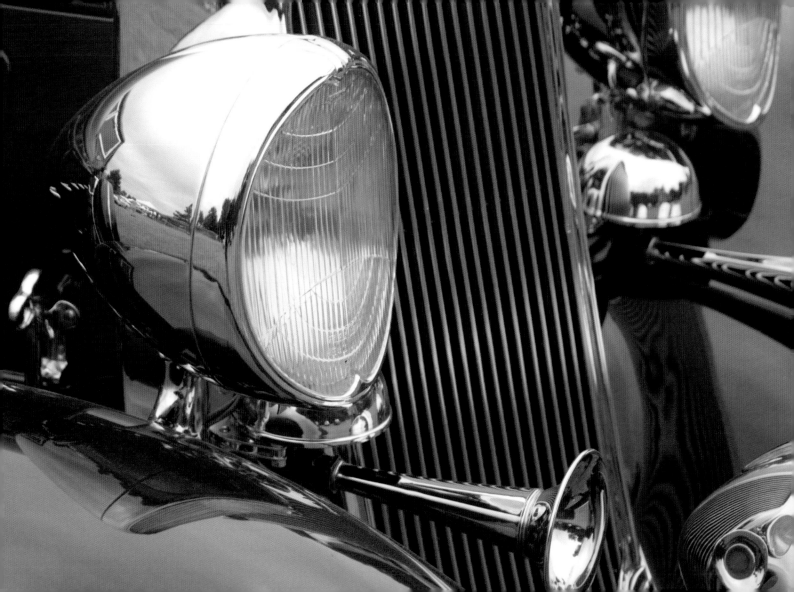

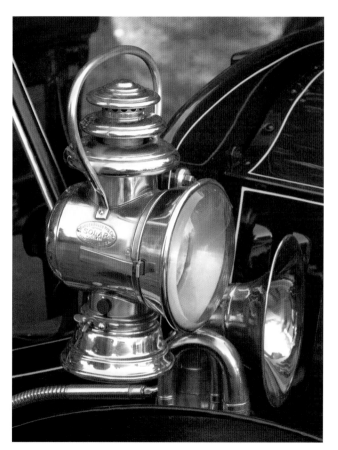

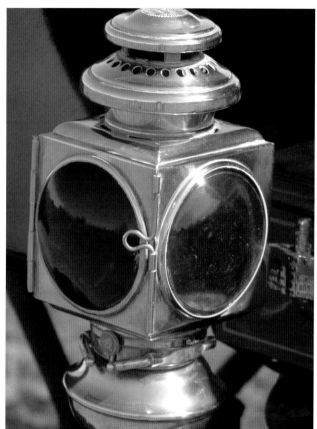

Yale, 1905; opposite, Chrysler, Imperial, 1933

Ford, Model T, 1911

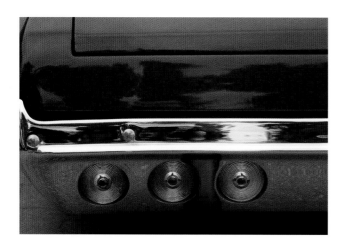

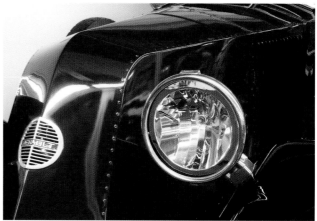

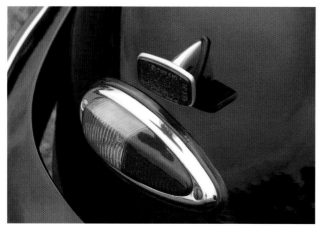

top, Chevrolet, Low Rider, 1971; bottom, Porsche, 356B Roadster, 1960

top, Renault, 1925; bottom, Chevelle, SS, 1969

Tucker, 1948

Ford, 1956

Thunderbird, 1962

162

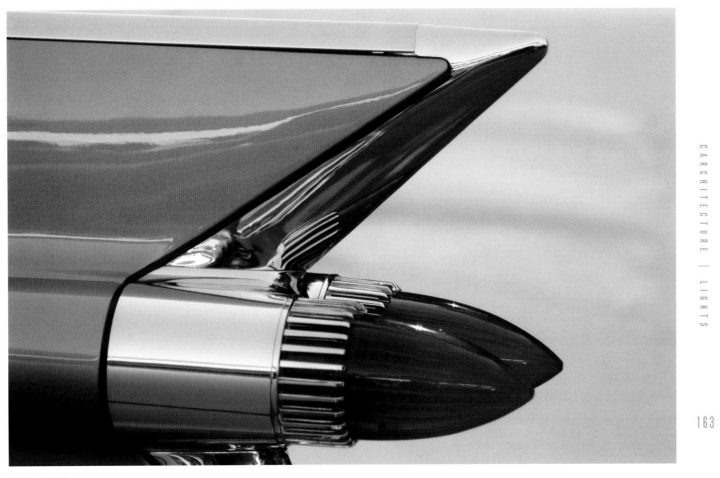

Cadillac, 1959

The most arbitrary of a car's attributes is its color. The carriage maker's craft of applying polished lacquer to thin veneers of wood evolved into the mass-production science of painting metal and plastic. The colors of cars themselves have varied wildly with fashion over the decades, ranging from dark and subdued hues to the riotous two and three tone schemes of the 1950s. Today's more subtle tones emphasize metallic finishes, with silver leading the pack in the United States.

165

Chevrolet, Hot Rod, 1934

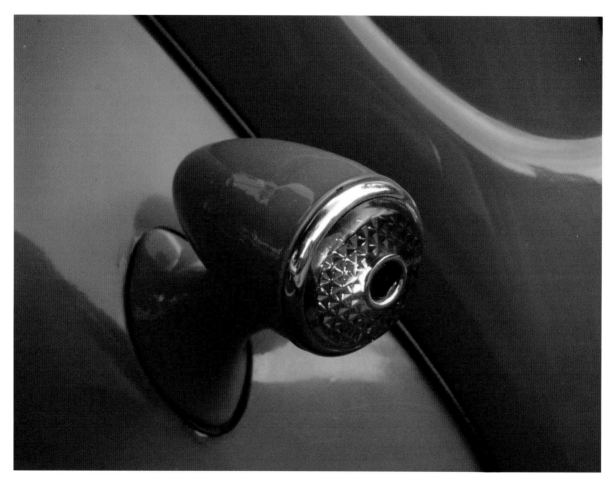

Ford, Custom, 1937; opposite, Riley, Special, 1933

168

Porsche, 914/6, 1971

Ford, Custom, 1937

top, Cadillac, 1958; bottom, Mercury, 1959

top, Jaguar, MkV, 1950; bottom, Prowler, 1999

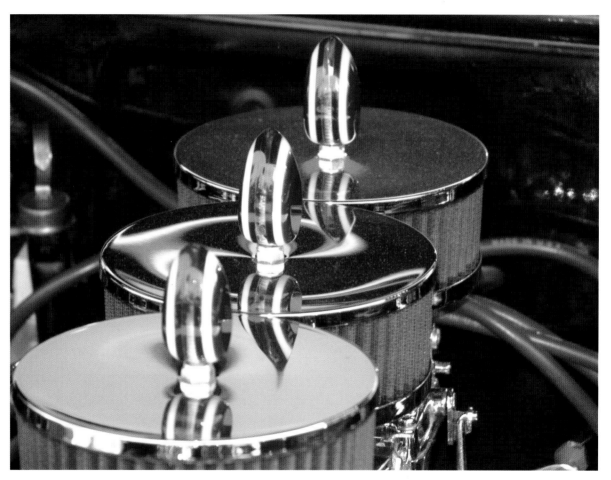

Mercury, Custom, 1950

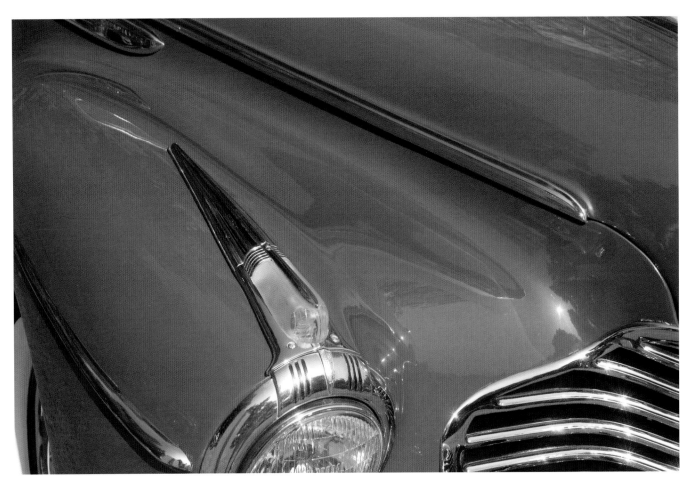

172

Buick, 1941

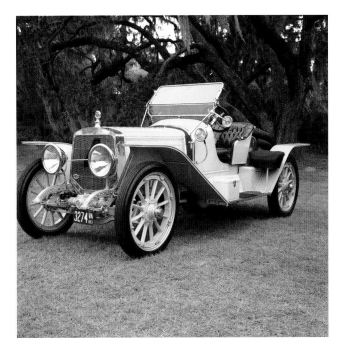

Lozier, Runabout, 1913

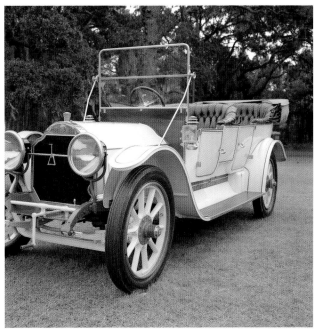

Garford, Six-Fifty, G-14, 1912

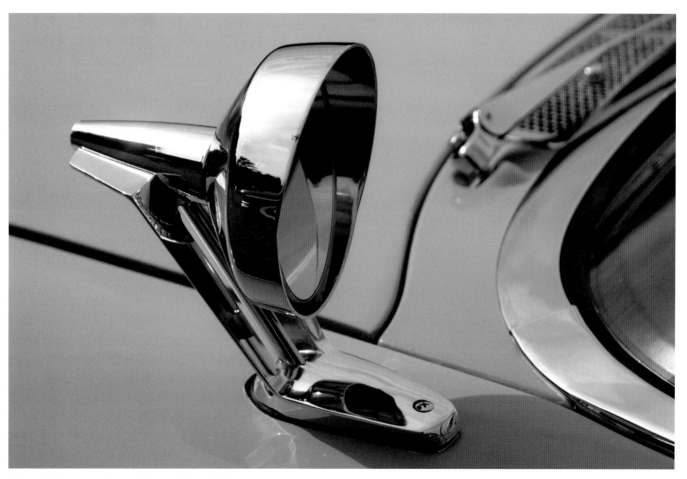

DeSoto, 1959; opposite, Mercury, Windshield Visor, 1950

176

Hudson, 1913

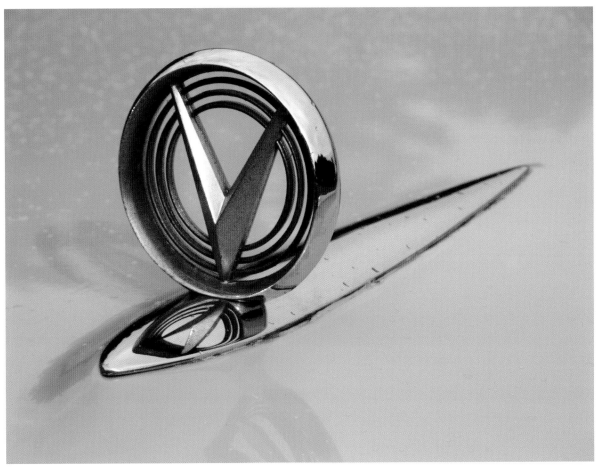

Buick, 1955

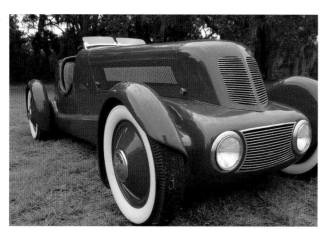

Ford, Model 40 Special, 1934

Chevrolet, Camaro, 1969; opposite, Plymouth, 1934

Ford, GT 40 Concept, 2006; opposite, Auburn Boattail, 1932

Dodge. Magnum 440. 1967

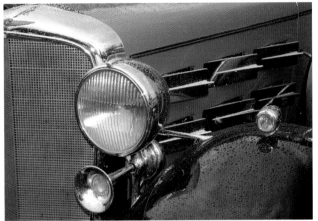
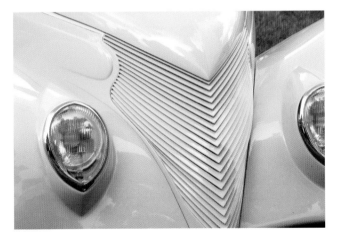

top, Stutz, 1931; bottom, Ford, Custom, 1937

top, Cadillac, V-8, 1933; bottom, Dodge, Magnum 440, 1967

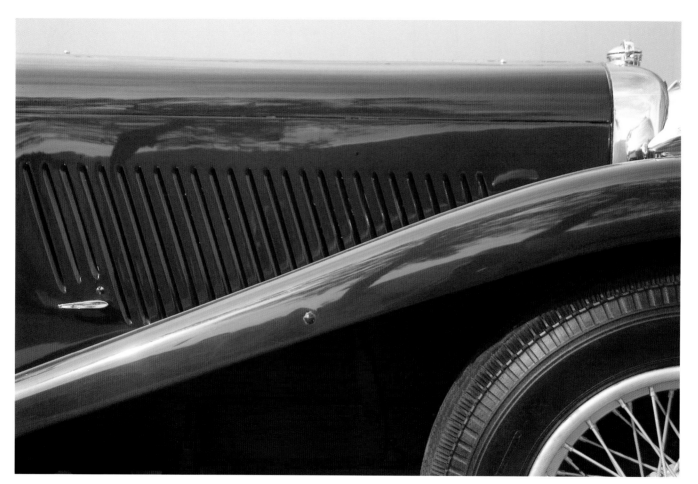

184

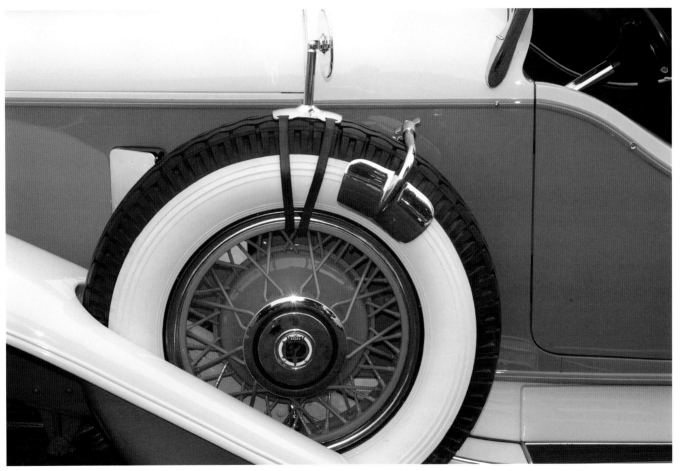

Stutz, Bearcat, 1931

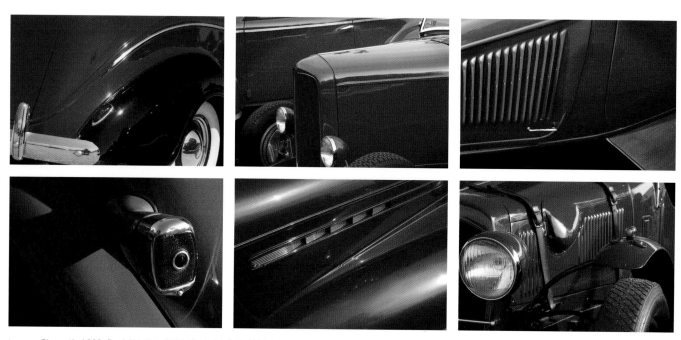

top row, Plymouth, 1933; Ford, Hot Rod, 1932; Ford, Hot Rod, 1934; bottom row: Chevrolet, 1938; Oldsmobile, Hot Rod, 1939; Aston Martin, Le Masstif, 1933; opposite, Chevrolet, Master Deluxe, 1936

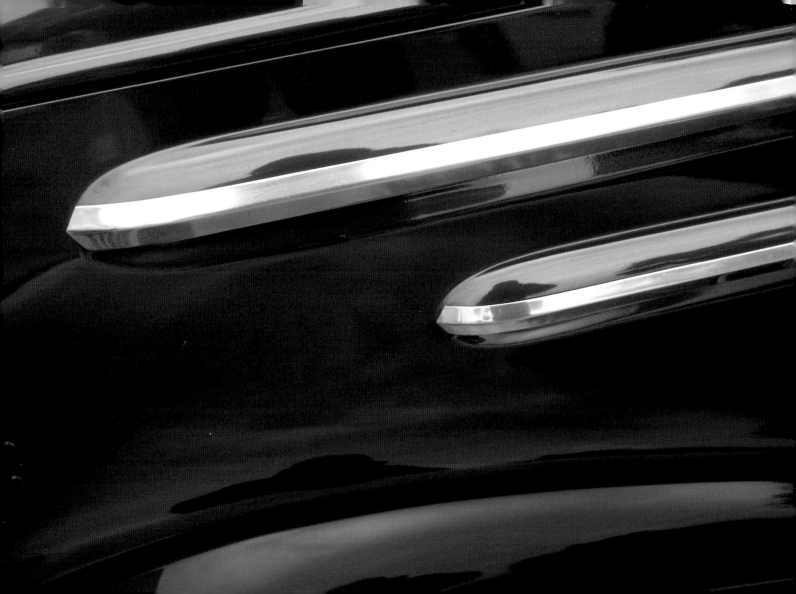

Willys, 1941: opposite (front) Lamborghini, Murcielago: (back) Gallardo, 2004

E M B L E M S

Justifiably proud of their creations, the makers of early cars blazoned their names in looping brass script across radiators and dashes. More symbols, coats of arms, hubcap emblems, radiator designs, and mascots grew into a complex and unique automotive heraldry that can only be hinted at here. No surface was sacrosanct.

Similarly, racing cars needed identification, starting with simple whitewashed numbers on radiators and gradually devolving into the riot of sponsors' decals that envelop today's NASCAR racers.

Edsel. Ranger. 1960

Stutz, Boat Tail, 1929

Frazer, 1947

top, Chevrolet, Bel Air, 1955; bottom, Lister Jaguar, 1958; opposite, Chevrolet, Camaro, 1970

top, Nascar Chevrolet, 2000s; bottom, Fiat, 124 Racer, 1968

Porsche, 356A, 1956

Bugatti. T-59, 1934

Bugatti, T-59, 1934

Pope Toledo, Racer, 1904

Chrysler, 300B, 1956

Ford. 1956

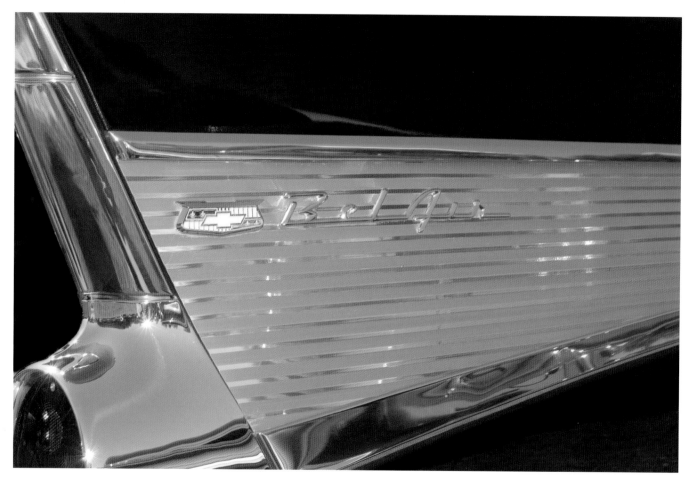

Chevrolet Bel Air, 1957

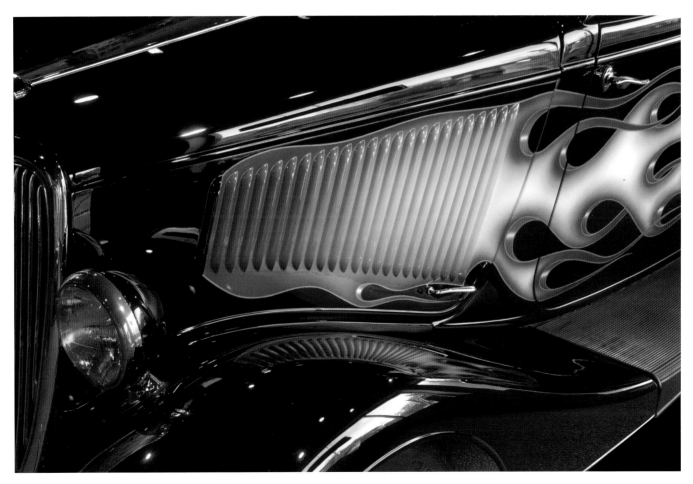

Ford. 3 Window Coupe. 1934

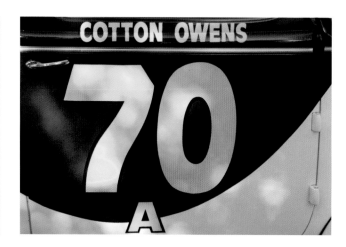

top, Riley, Register Racer, 1934; bottom, BMW 328, 1936

top, Plymouth, Racer, 1930s; bottom, Cooper T-51, 1959

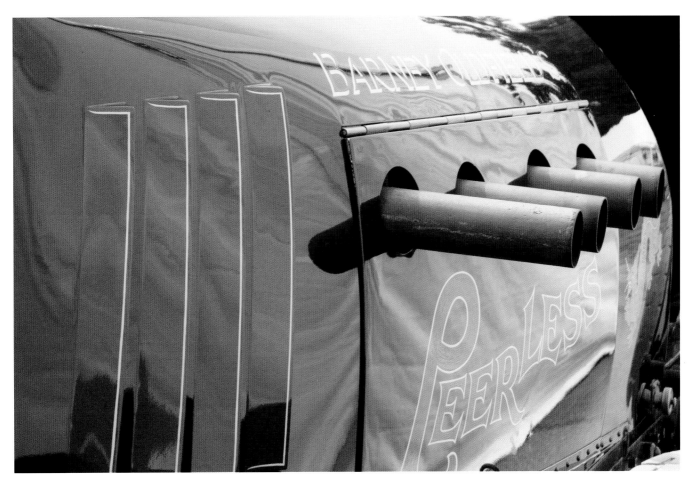

Peerless, Green Dragon Racer, 1904

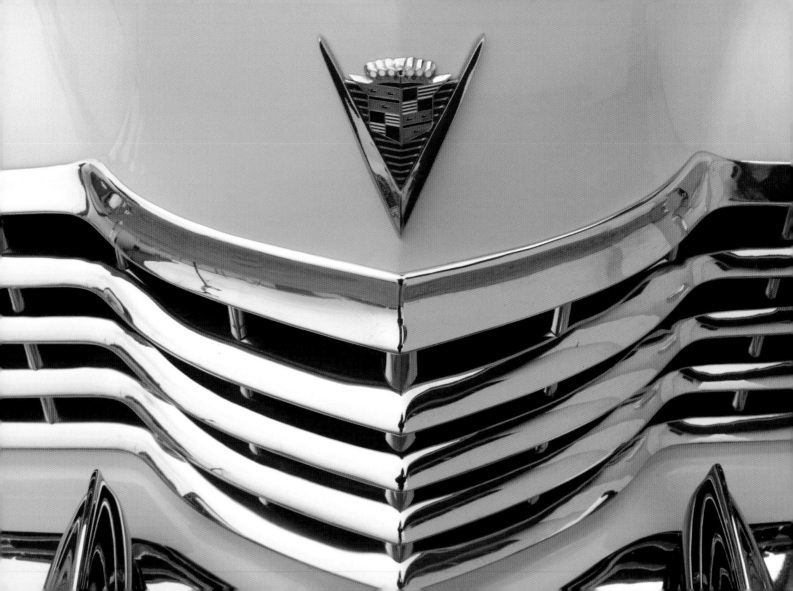

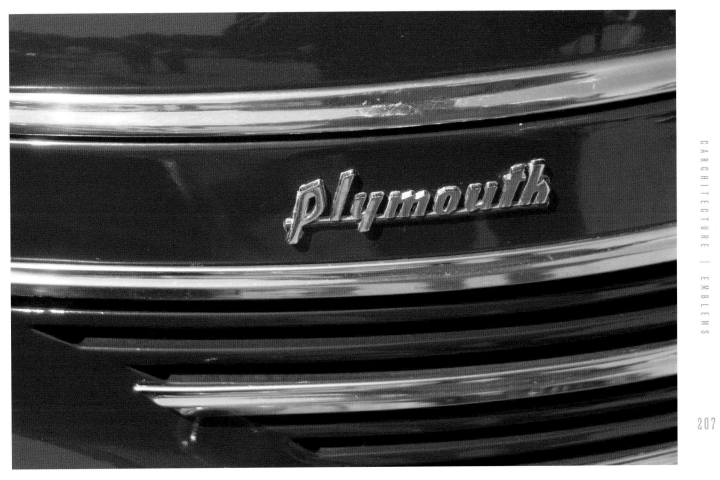

Plymouth, 1946; opposite, Cadillac, 1947

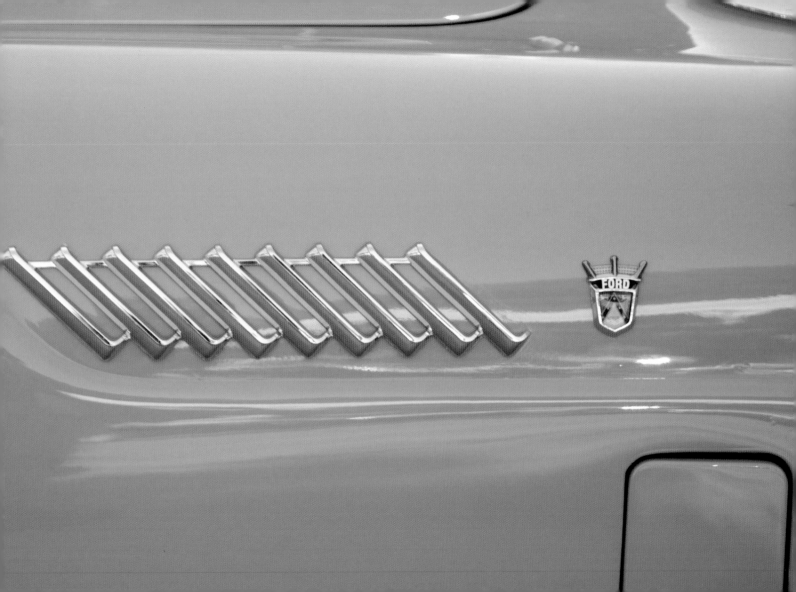

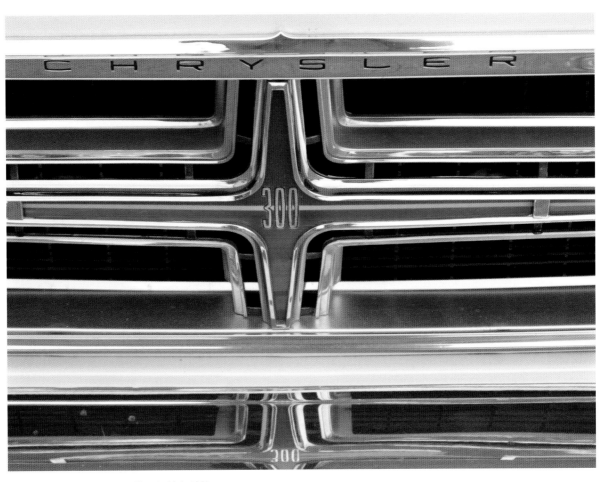

Chrysler 300 K, 1964; opposite, Thunderbird, 1956

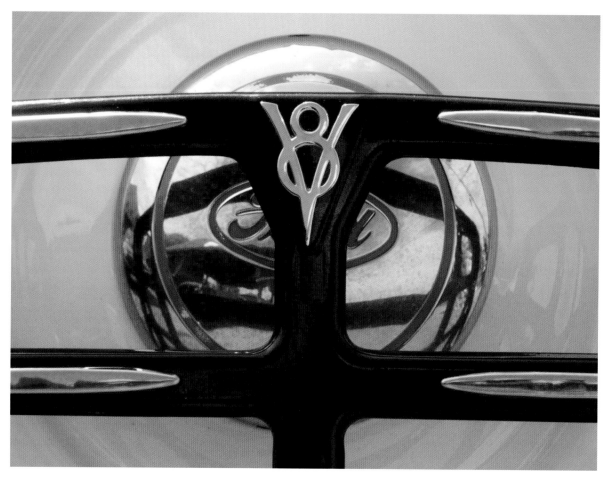

Ford V-8, 1936

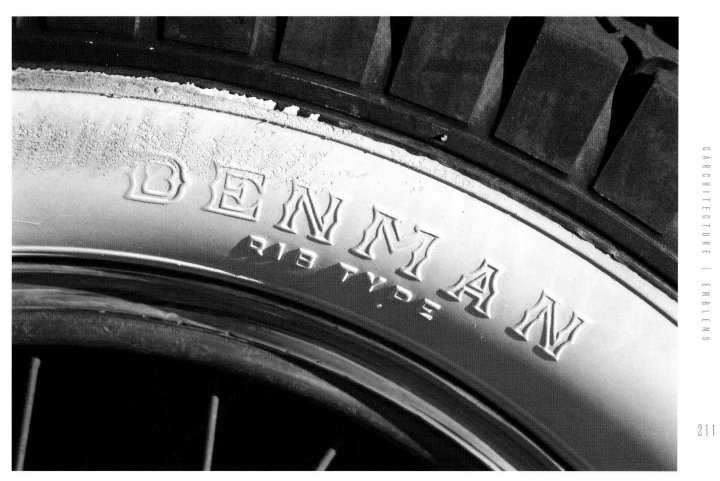

Denman tire, 1920s

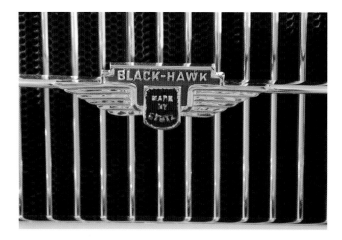

top, Stutz, Blackhawk, 1929; bottom, Audi, 1930s

top, Rolls Royce, 1930s; bottom, Morgan +4, 1960s

Ford, Victoria, 1956

Simplex, Speedcar, 1908

Morgan +4, 1960s; opposite, Cadillac, Model A Sports, 1903

Ford. Model T, 1911

Simplex, Speedcar, 1908

220

Bugatti. T-57C. 1936

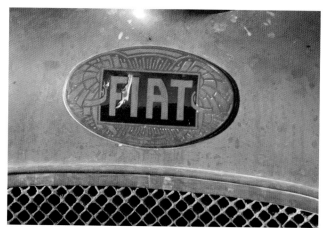

top, REO, 1907; bottom, Chevelle SS 396, 1969

top, Chevrolet, Parts, 1957; bottom, Fiat, 1923; opposite, Chevrolet, Custom Hot Rod, 1939

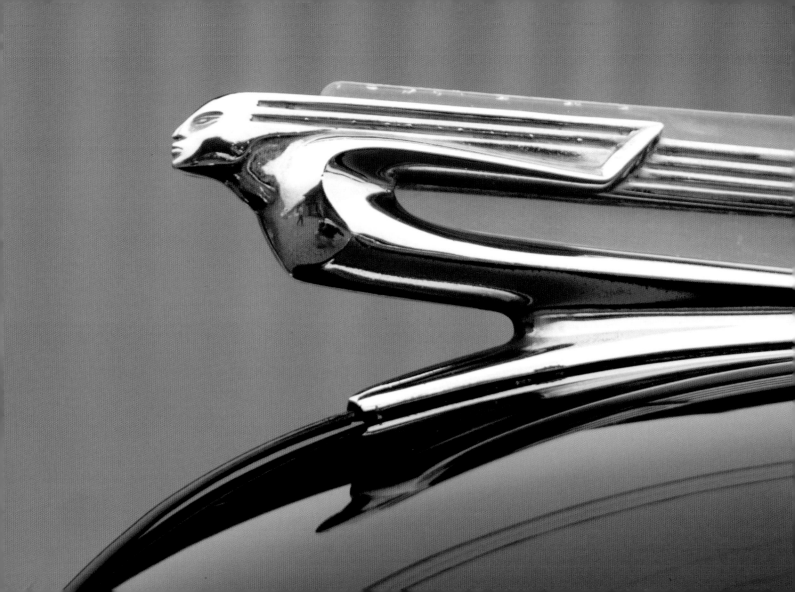

METAPHORS

The car stands on its own as a functional transport, but its makers typically felt that their creations should stand for something and embody the gods of speed, represent the ultimate in luxury, or symbolize the excitement of the future. These totemic symbols came to be focused atop the radiator at the front of the car. Called mascots or hood-ornaments, these powerful chrome sculptures gradually morphed with the spirit of the times into futuristic rocket shapes that sprawled across the hoods of mid-century cars. They have mostly disappeared today, and our autos are diminished by their absence.

225

Chevrolet, 1940

226

Plymouth, 1937

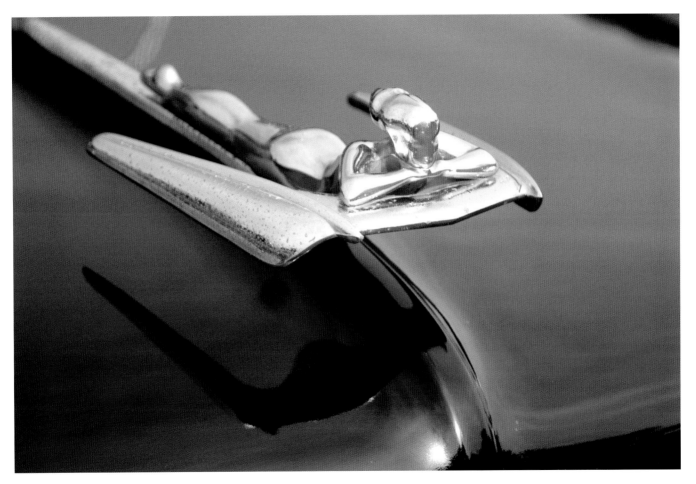

Nash, 1954

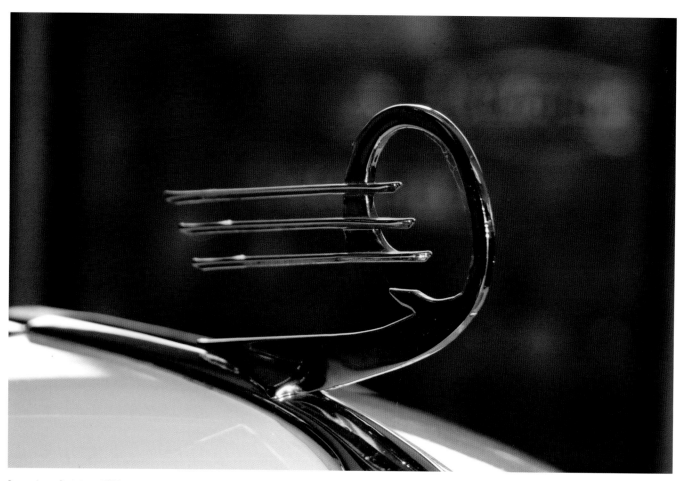

Duesenberg, Prototype, 1936

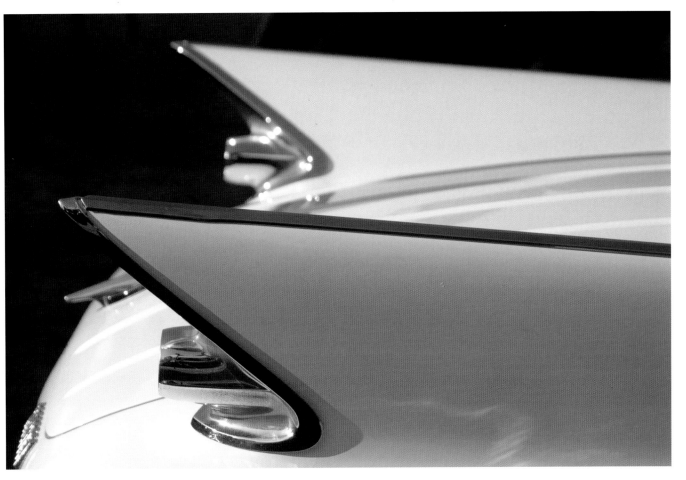

Chrysler, 1961

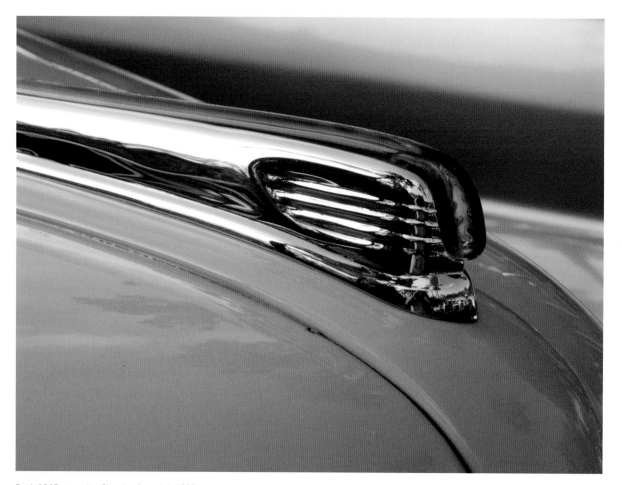

Ford, 1947; opposite, Chrysler, Imperial, 1932

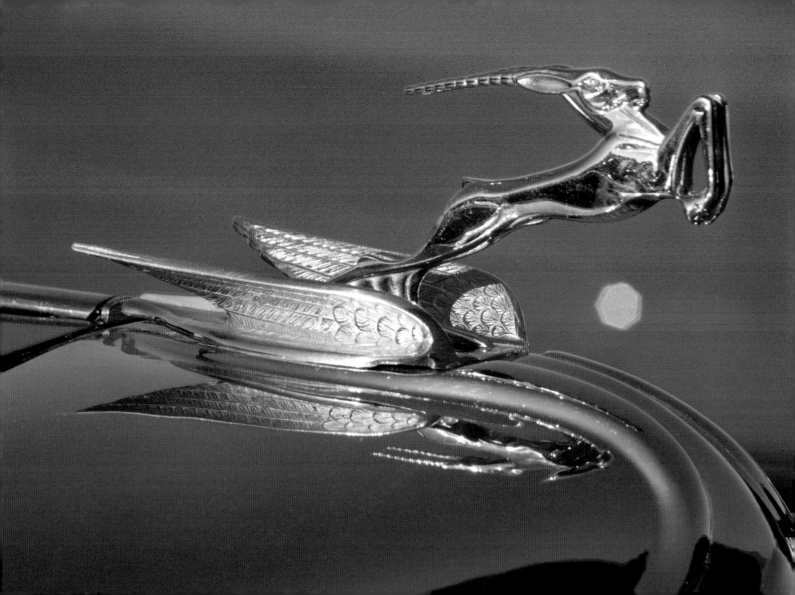

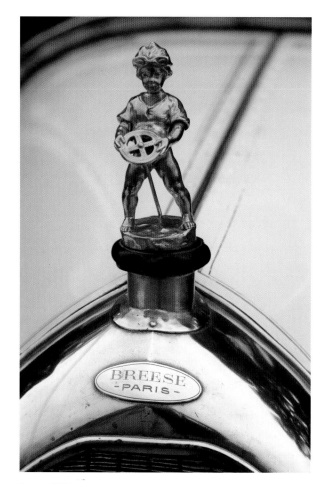

Breese, 1911

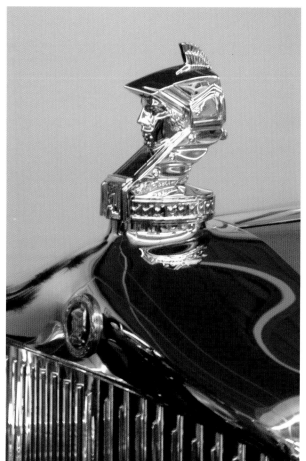

Minerva, 1931

Plymouth, Hot Rod. 1930s

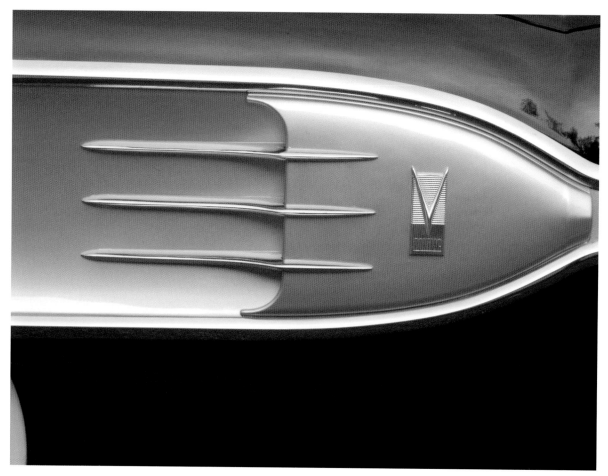

234

Pontiac, 1958

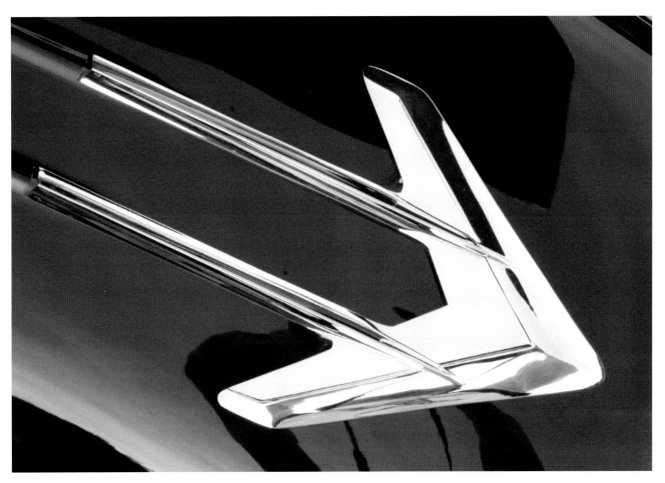

Pontiac, 1958

Chrysler, 1955; opposite, Buick, 1948

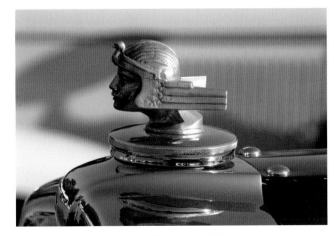

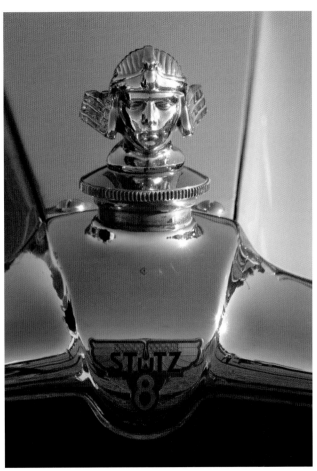

top, Marmon, 1931; bottom, Stutz, "Ra" Mascot, 1920s; opposite, Chrysler 300 C, 1957

Stutz, "Ra" Mascot, 1920s

Studebaker, 1941

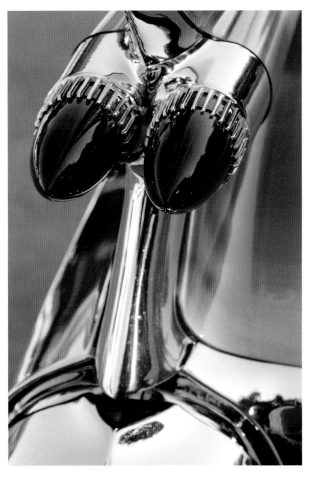

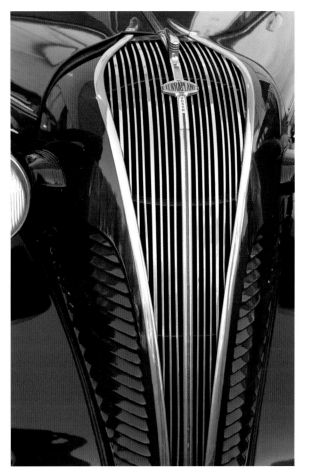

Cadillac, 1959

Terraplane, 1937

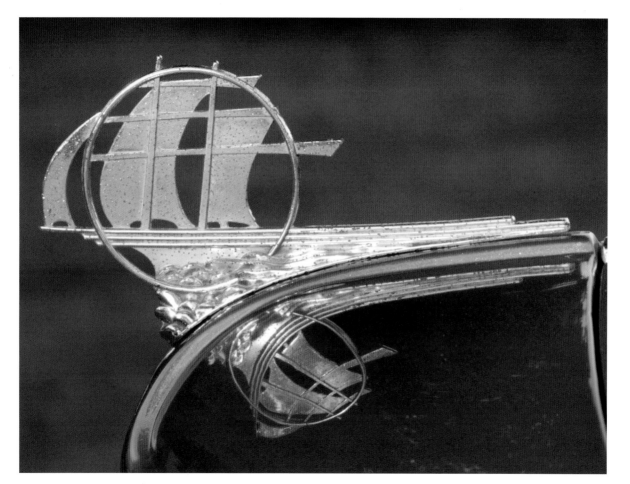

242

Plymouth, Custom, 1934; opposite, Pontiac, Custom, 1930s

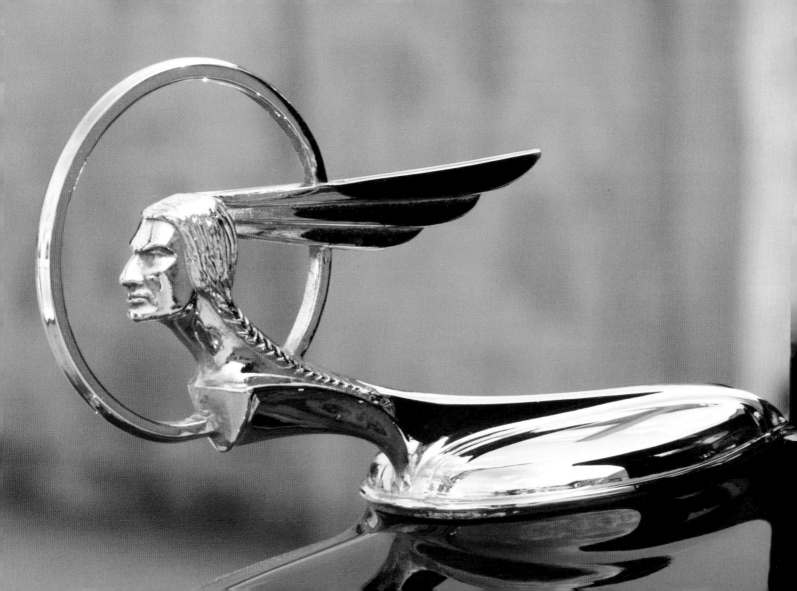

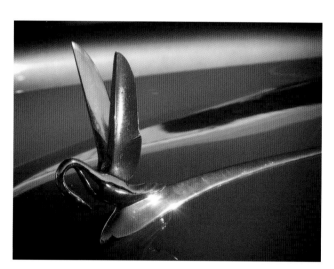

Packard, 1951

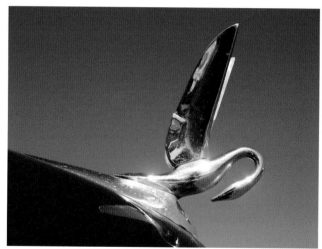

Packard, "Swan," 1950s; opposite, Kaiser, Virginian, 1949

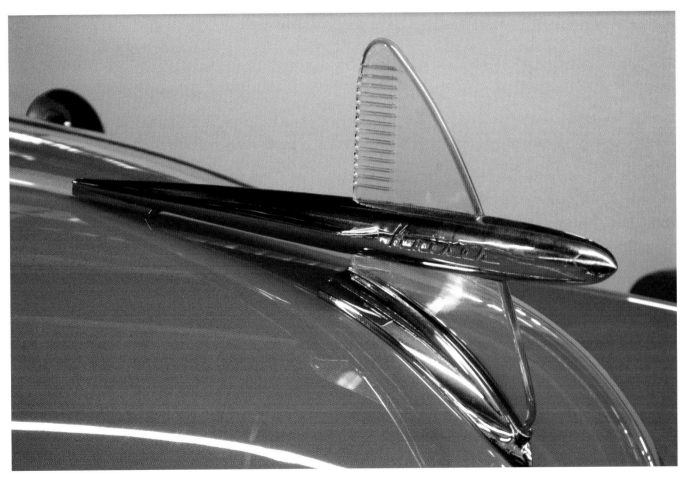

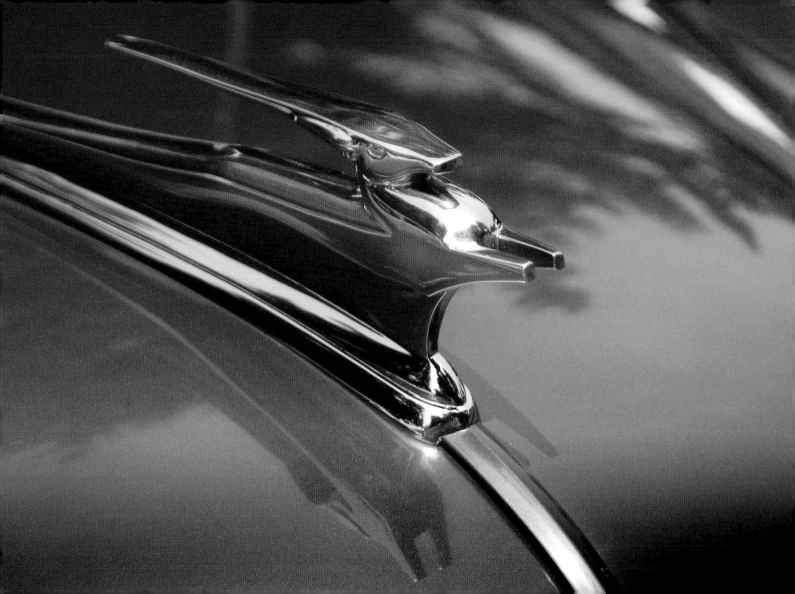

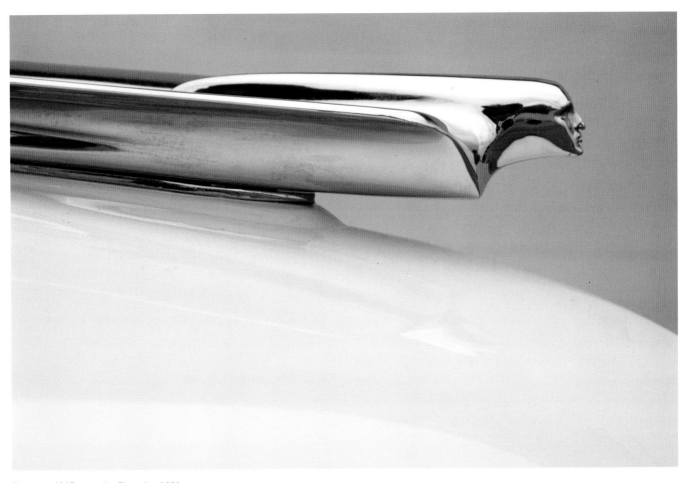

Chevrolet, 1947; opposite. Chevrolet, 1951

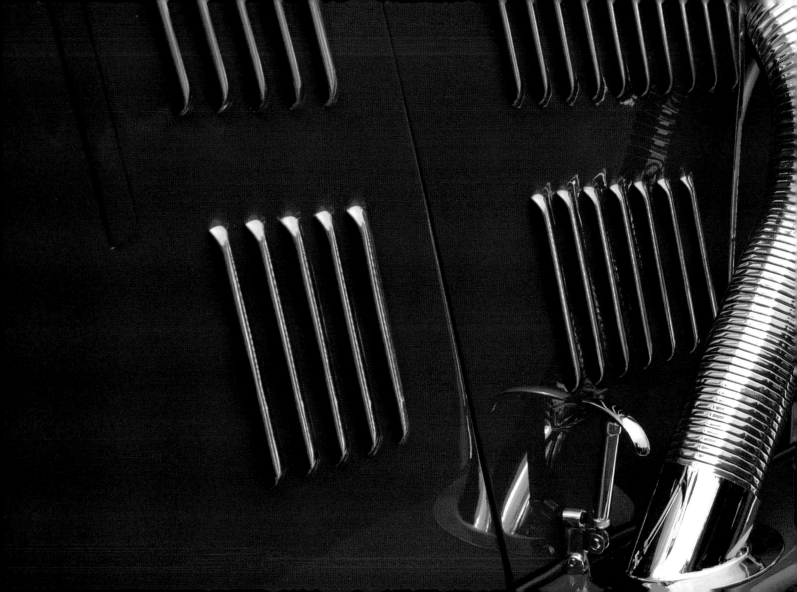

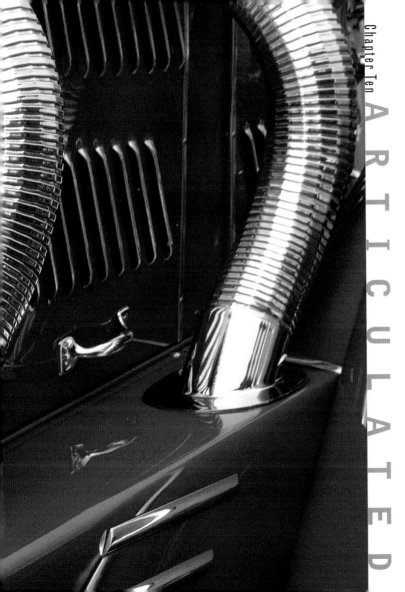

ARTICULATED

Though it seems all of a piece, today's car is a microchip-complex assemblage of systems and sub-assemblies. Even ignoring engine and powertrain issues, wheels must bounce, convertible tops must retract, doors must open and lock, and windows must slide and pivot. Early carmakers delighted in every ingenious mechanism for its own sake, showing them off for fascinated customers. Now details are usually expressed in more elegant and subtle ways.

Mercedes Benz, 500K, 1934

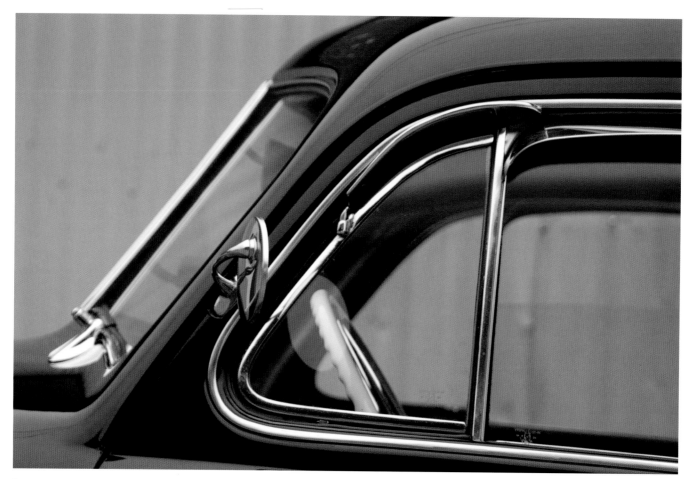

Chevrolet, 1940

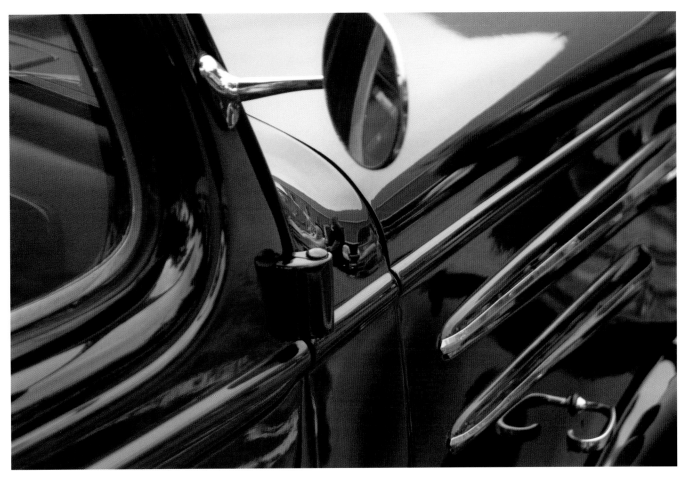

Chevrolet, Master Deluxe, 1936

252

Lagonda, 1939

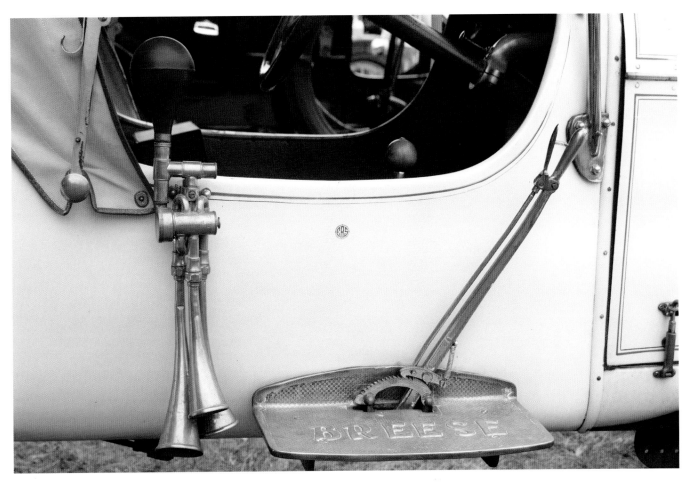

Breese, 1911

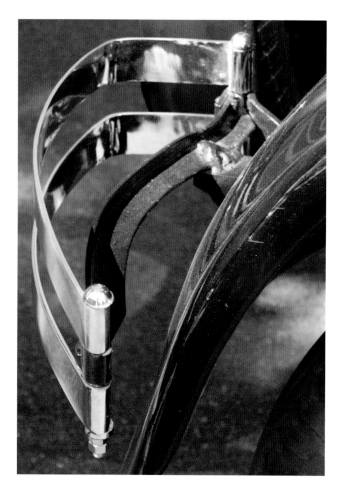

Ford, Model T, 1927

Stutz, 1929

Chevrolet, 1932

Jaguar, Mk V, 1950

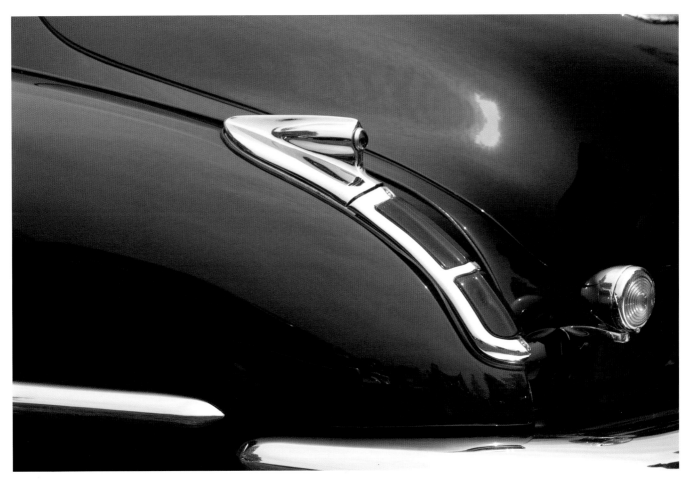

Cadillac, 1947

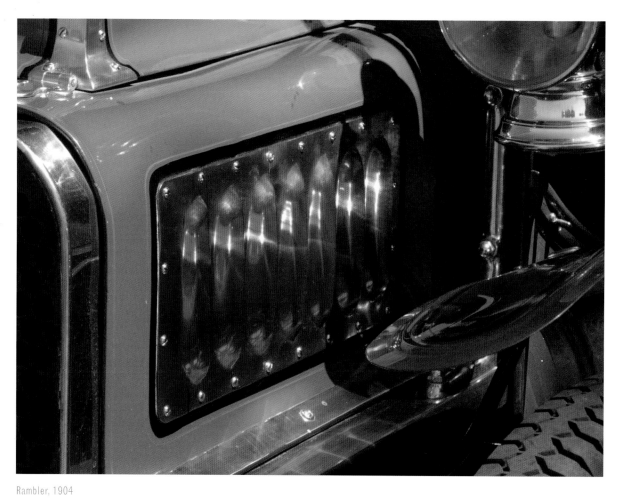

Rambler, 1904

Sunoco, Racer, 1968

Packard, 1929; opposite, Chrysler, 1932

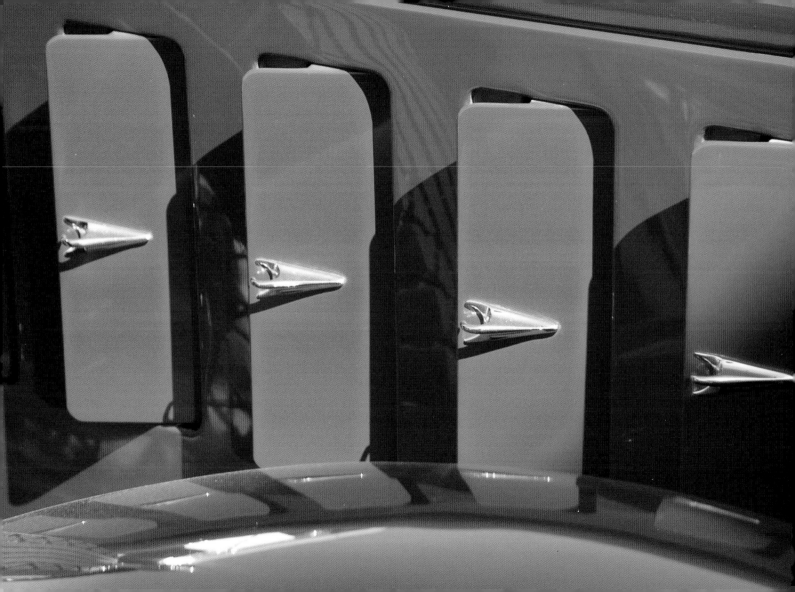

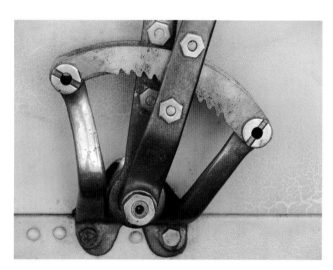

Pope Toledo, Racer, 1904

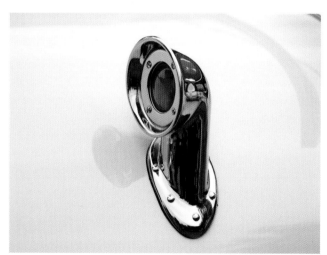

Daniels, 1921

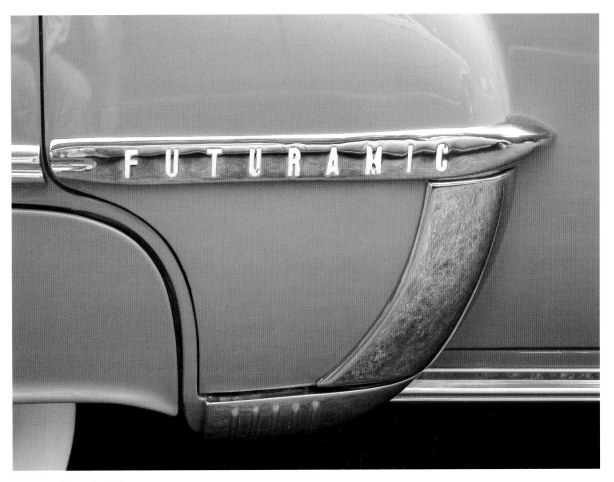

Oldsmobile, Futuramic, 1950

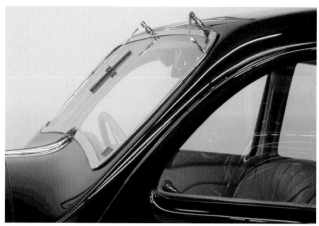

top, Mercedes Benz, 320, 1938; bottom, Ford, 1932

top, Rolls Royce, Phantom II, 1932; bottom, Unidentified, Racer, 1940s

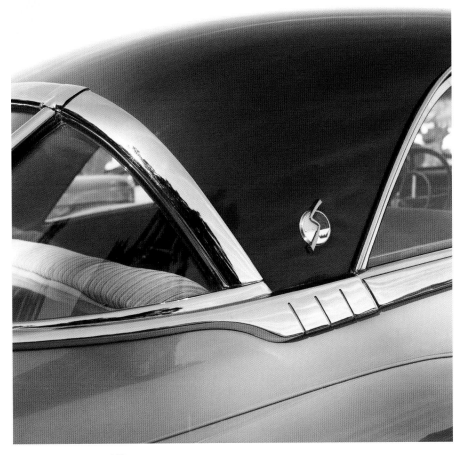

Studebaker, Champion, 1952

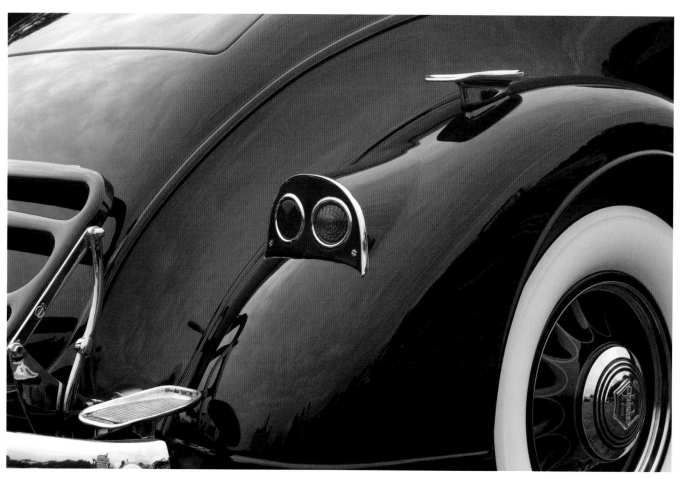

Pierce Arrow, 1935

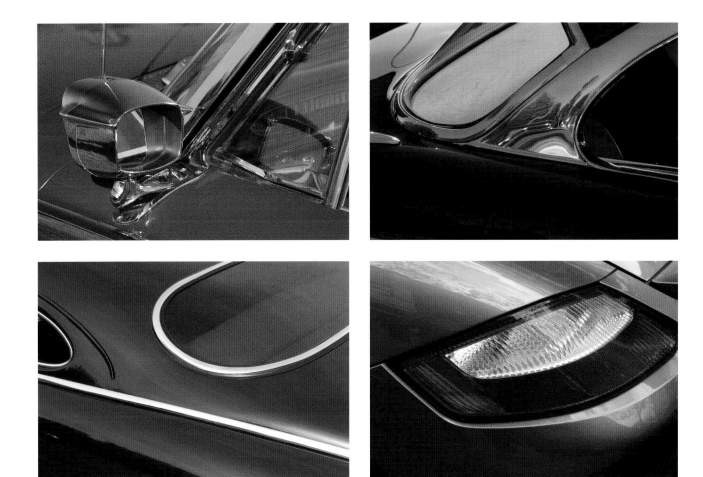

top, Edsel, 1960; bottom, Mercury, 1950

top, Chevrolet, 1957; bottom, Porsche, 2006

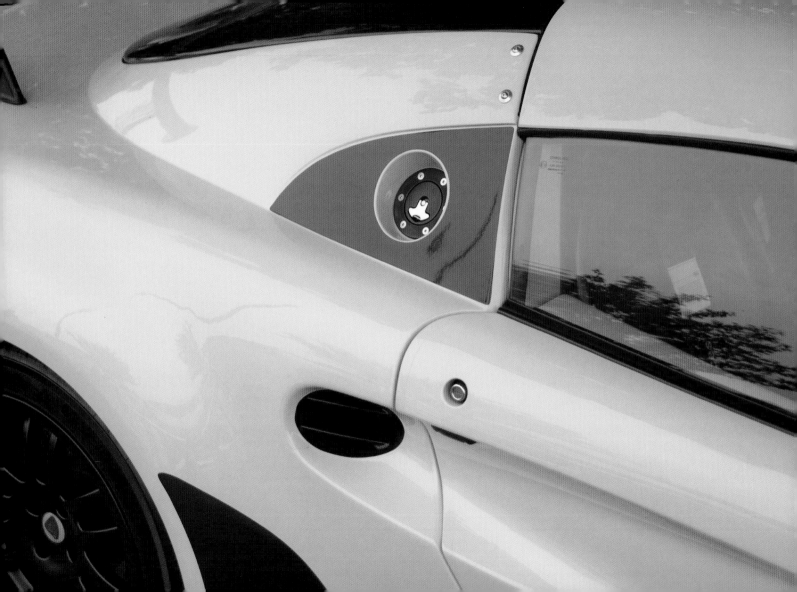

Chrysler, ME 4-12, 2004; opposite, Lotus, Exige, 2000

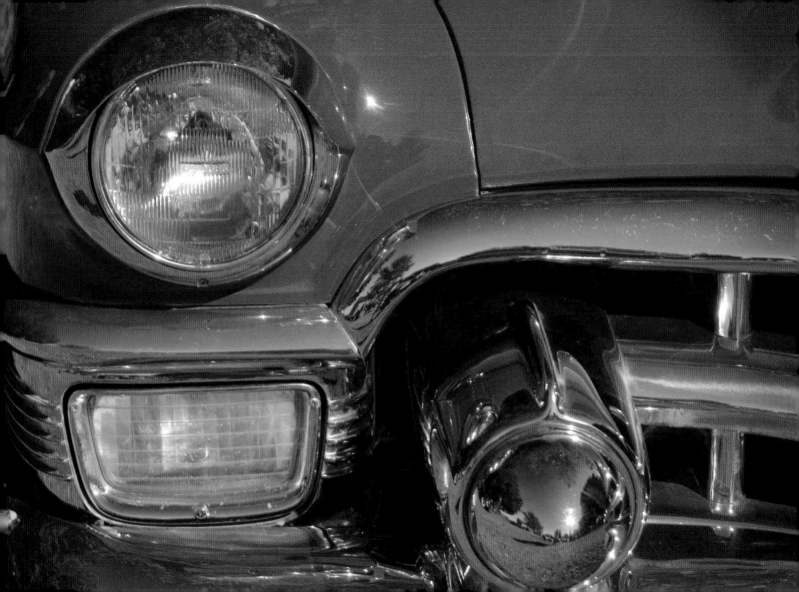

Chevrolet Bel Air,1957; opposite. Cadillac Eldorado. 1953

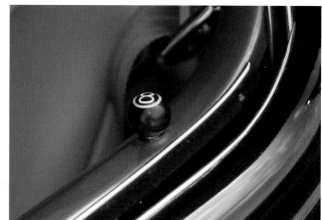

top, Jaguar MKV Drophead; bottom, 1950; Franklin, 1905

top, Ford, Model A, 1930; bottom, Chevrolet, Hot Rod, 1938; opposite, Pontiac, Starfire, 1958

274

Lagonda, 1939

BMW. 328. 1937

Rolls Royce, Silver Ghost, 1910

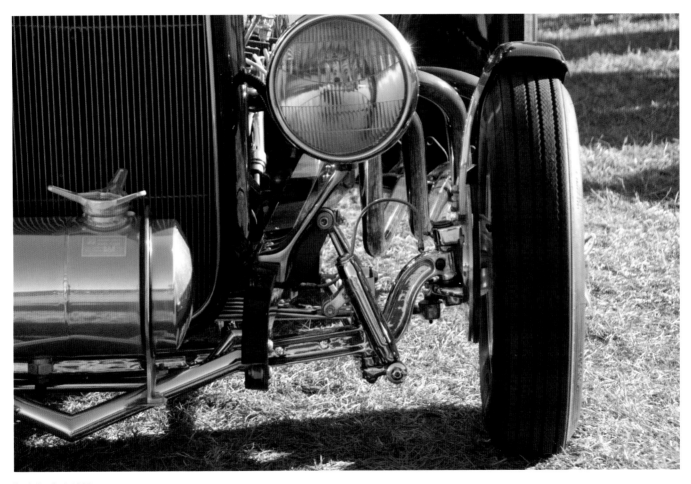

Ford, Hot Rod, 1932

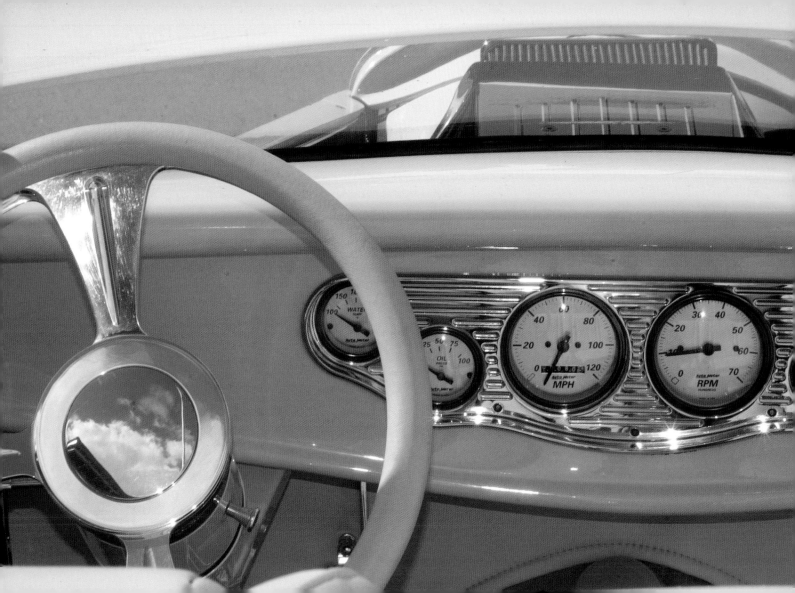

INTERIORS

It may resemble a high-tech cockpit or high-style drawing room, but the car's interior is where the driver grabs the wheel and takes control. As autos evolved and the front seat came under cover, drivers were confronted less with heroic levers and rods and more with dials and switches. The hands-on steering wheel remains a relic from the early brute-force era, whether as the centerpiece of a bare-bones Formula-one beast or of a car made to resemble a fantasy spaceship or the woody office of a pipe-smoking country squire.

279

Ford, Custom Hot Rod, 1933

Chevrolet, 1960; opposite, Chevrolet, 1963

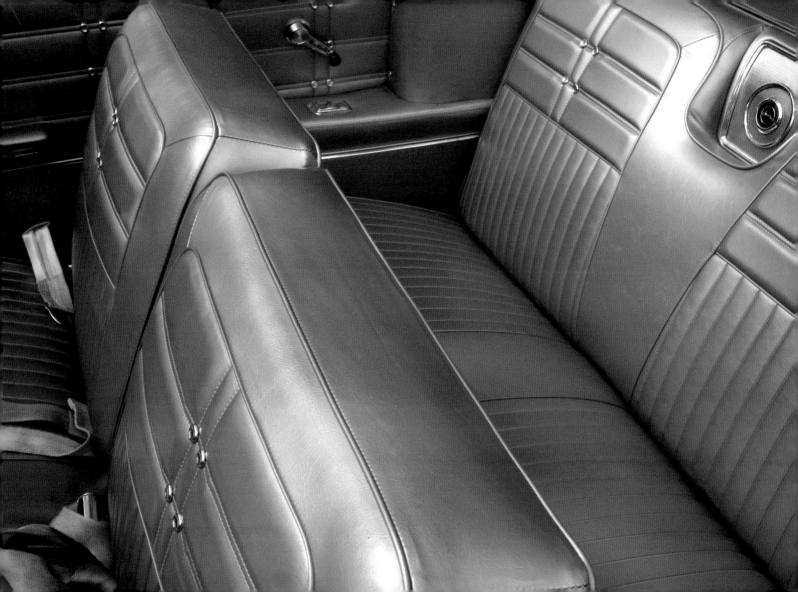

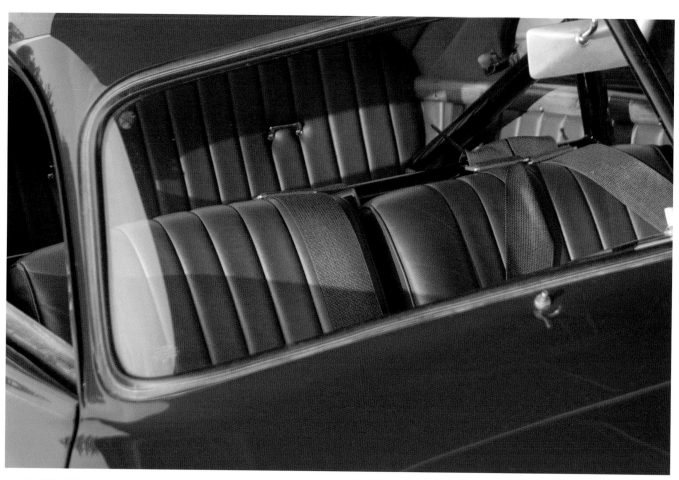

Porsche 1500, 1953

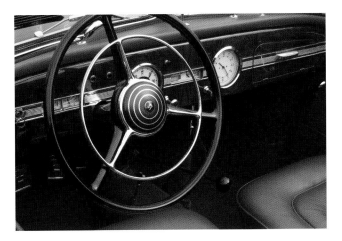

Horch 855, 1938

Ford, 1950

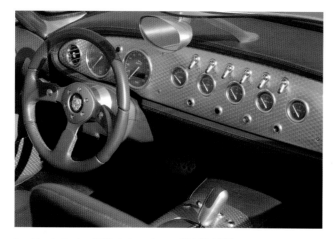

top, Lincoln Zephyr, 1939; bottom, Jaguar XK-180, 1999

Chevrolet, 1940

Stutz Blackhawk, 1929

286

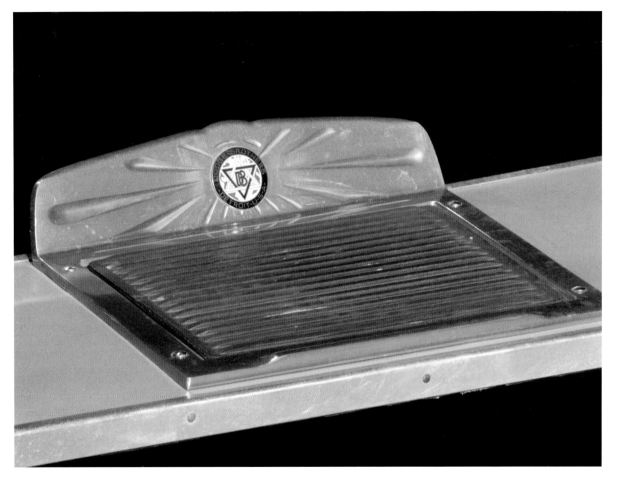

Dodge, 1923

288

Cadillac, 1927

Chevrolet, Custom, 1940s

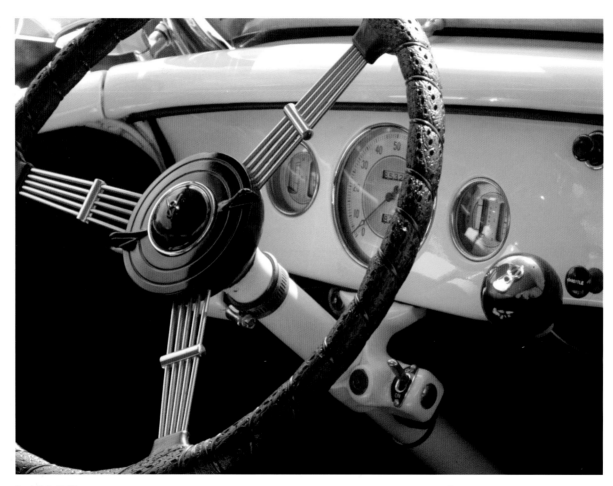

290

Ford, V-8, 1936

Chrysler, Imperial. Official NYC Parade Car. 1952

292

top, Cadillac, 1938; bottom, Mercury, Custom, 1950

top, Ford, 1950; bottom, Packard, 1948

294

Yale, 1905; opposite, Custom, 1930s

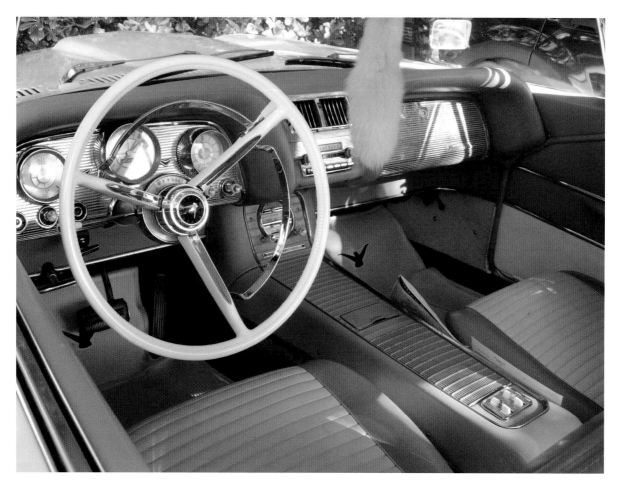

296

Ford, Thunderbird, 1958

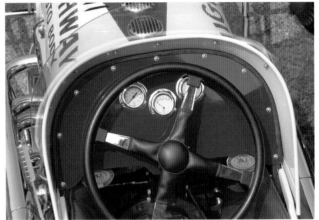

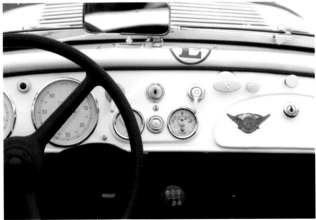

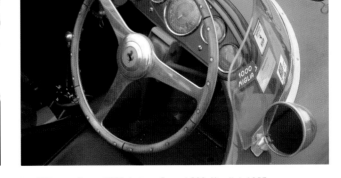

top, Siata 140C, 1953; bottom, BMW 328, 1936

top, Hillegass Racer, 1956; bottom, Ferrari 500, Mondial, 1957

Ford. 1947

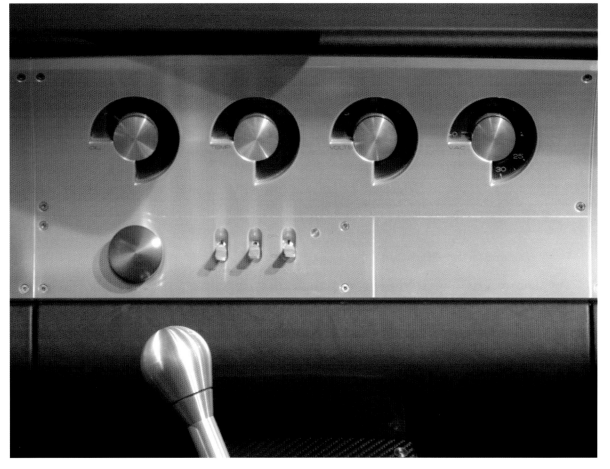

Shelby Cobra Concept, 2004

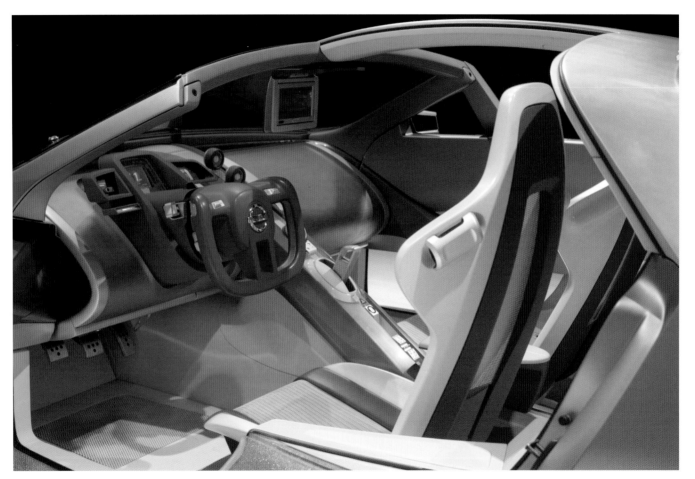

Nissan, Urge Concept, 2006

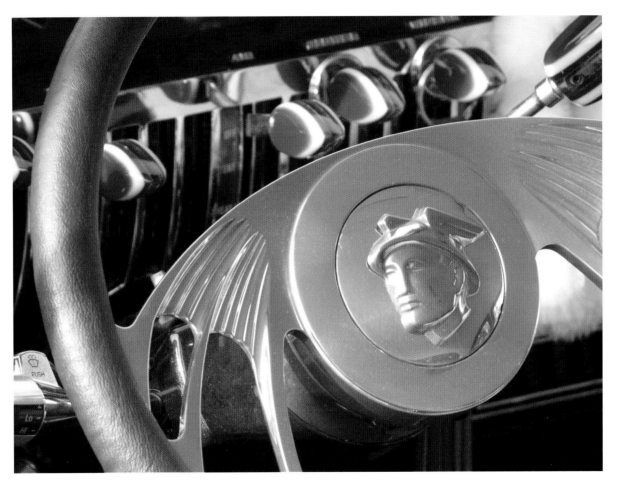

Mercury, Custom, 1950

302

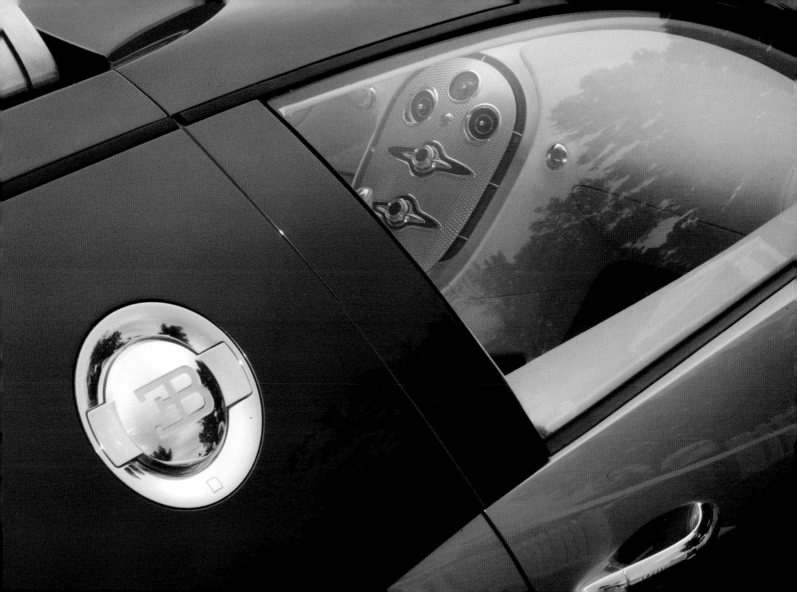

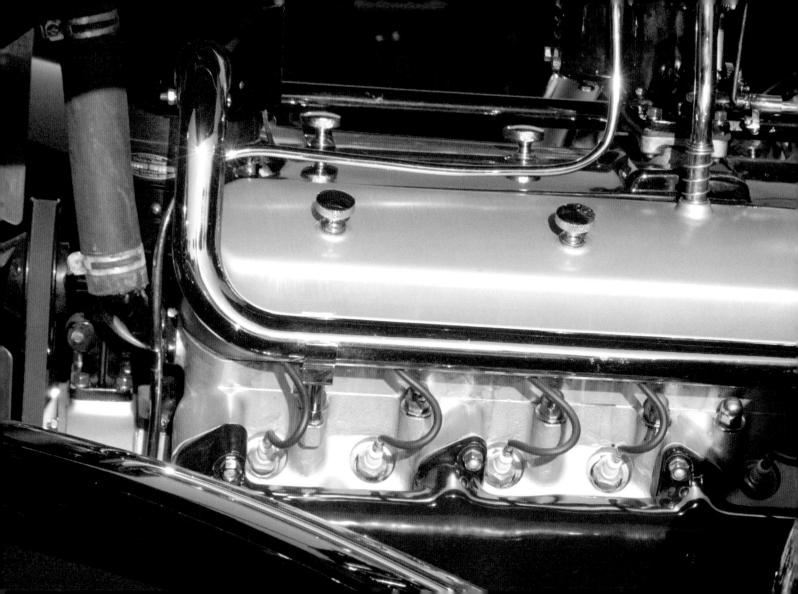

ENGINES

But the car is after all a machine; the engine block and gear-train are needed to make an auto mobile. Usually hidden under discreet layers of sheet metal, but with hood scoops and exhaust stacks hinting at the power within, motors are celebrated for their own sake as they crouch glinting in their dark engine compartments, and given names evocative of magical power: Little Hercules, V-8, Twin Six, Red Ram, and, of course, the immortal Hemi.

Marmon 16, 1931

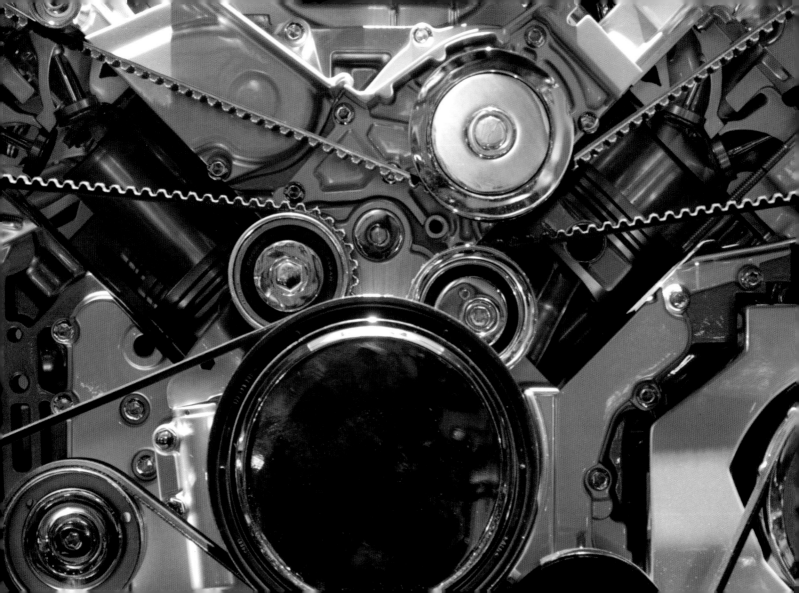

Dodge, Superbee, 1970; opposite: Nissan, Titan Truck, 2004

308

MG, TD, 1953; opposite, Jaguar, Mk V, 1950

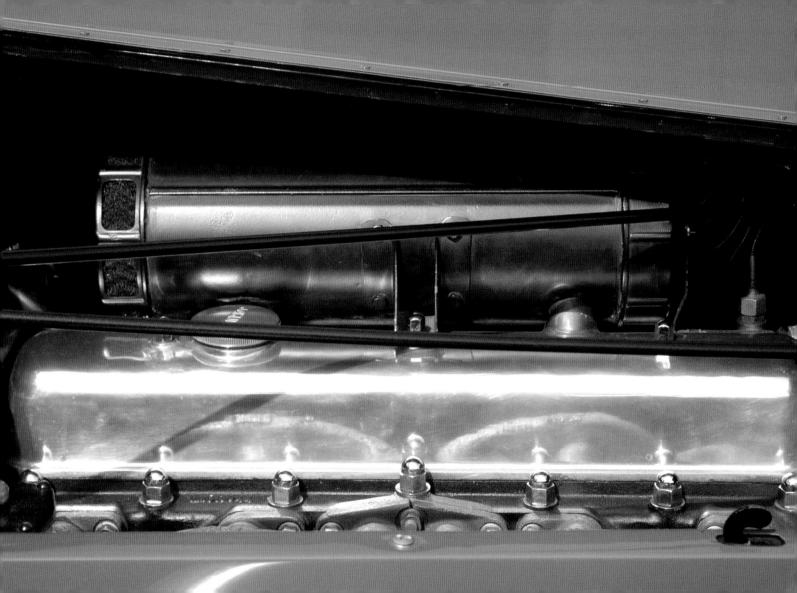

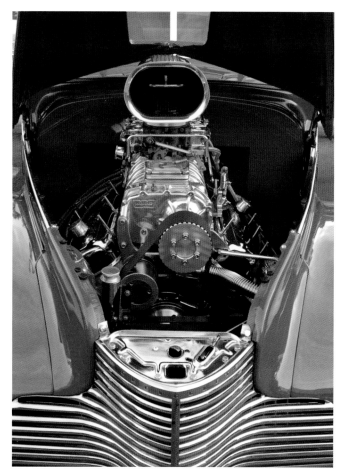

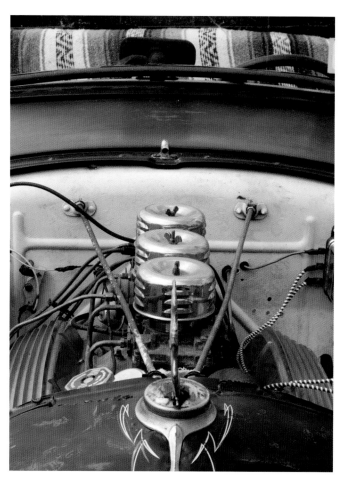

310

Chevrolet, Special Deluxe Custom Rod, 1940

Ford, "Rat Rod," 1930s

Ford, 1934

Sandford, Grand Sport, 1923

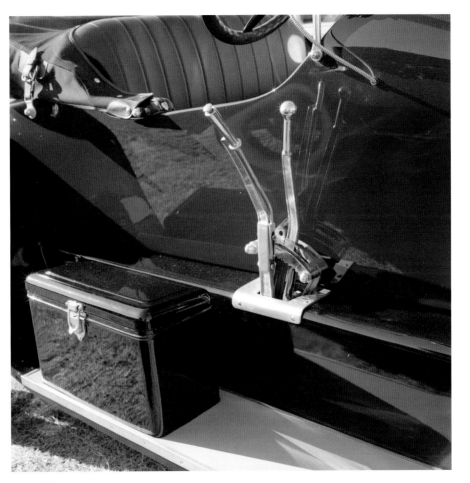

Stutz, 1923

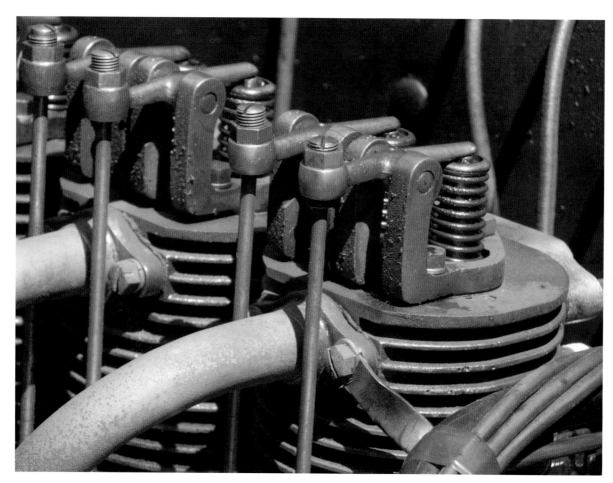

314

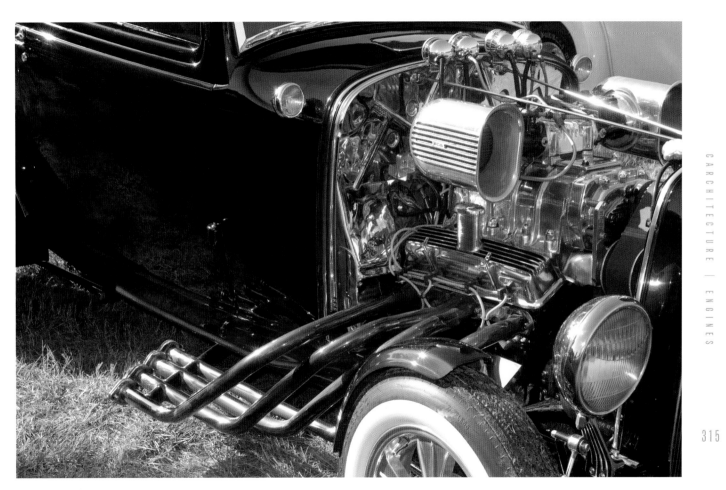

Ford. Hot Rod. 1930s

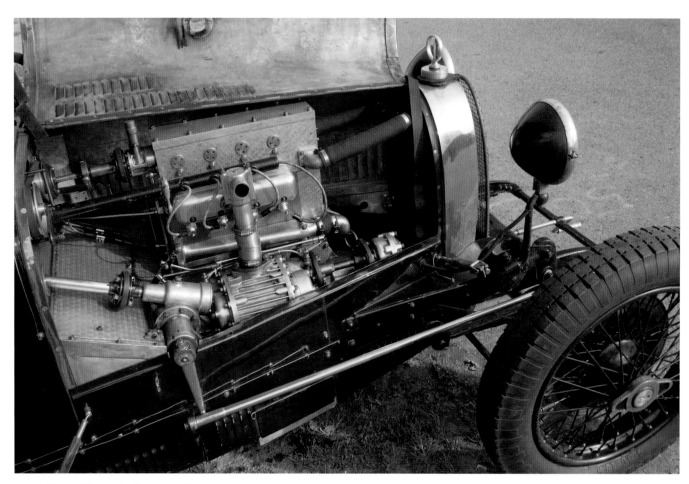

Bugatti, T37A, 1929; opposite, Chevrolet, 1938

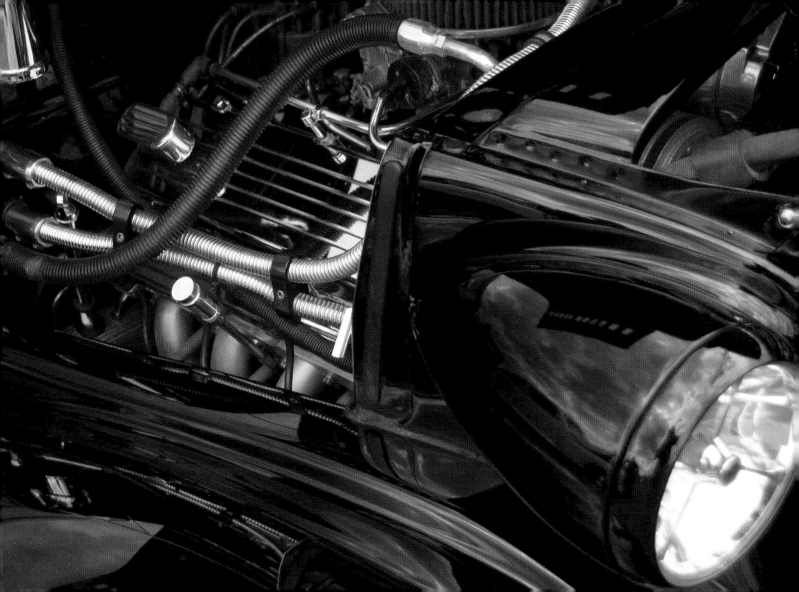

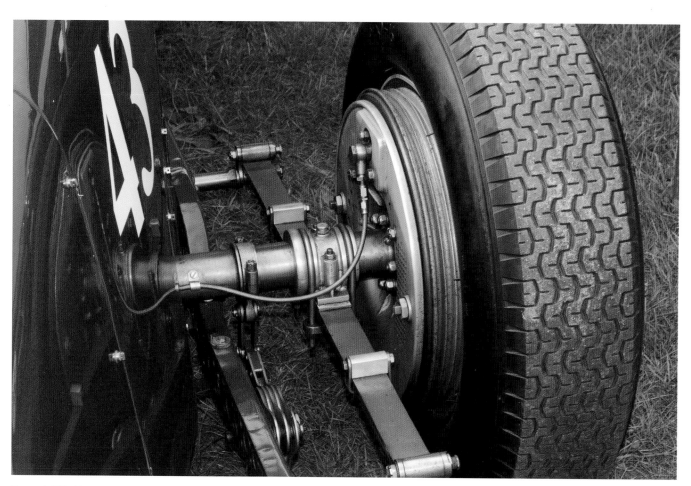

Maserati, 6CM, 1937

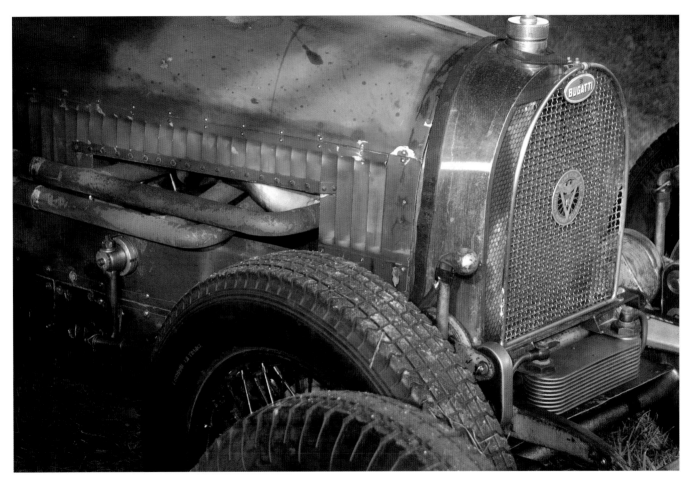

Bugatti, T35B, 1928

Sandford, Grand Sport, 1927; opposite: Simplex, Speedcar, 1908

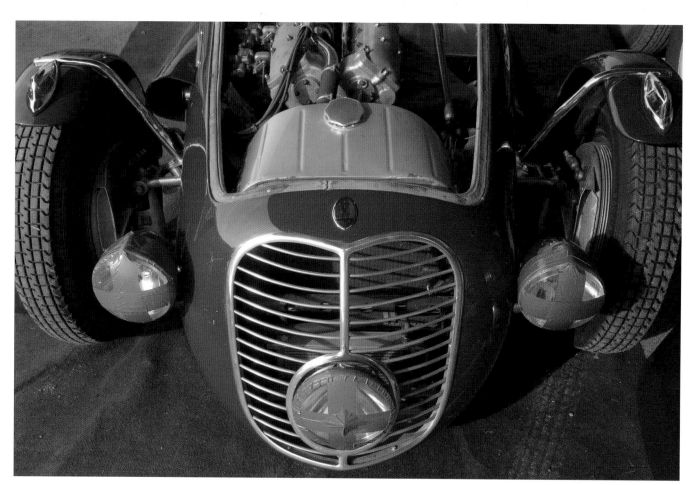

Maserati, A6GCS, 1950

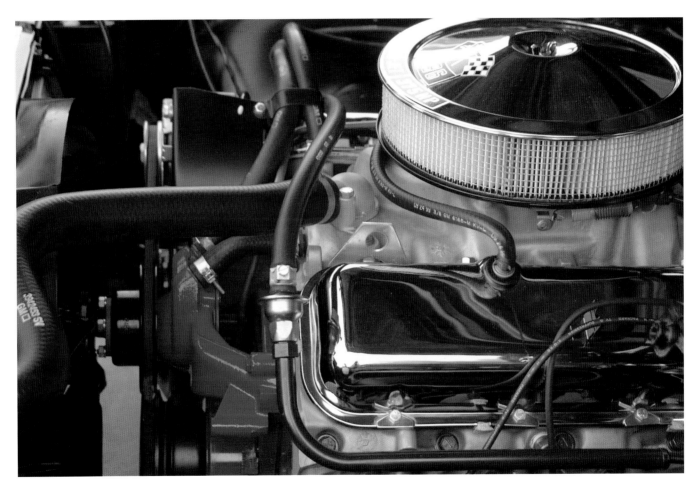

Chevrolet, Custom, 1960s

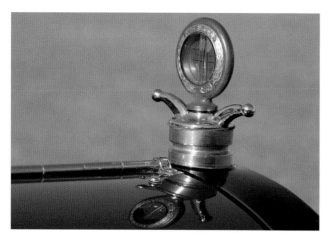

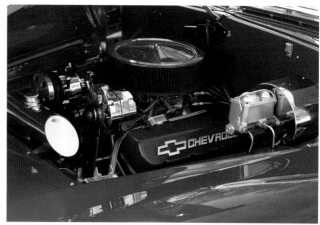

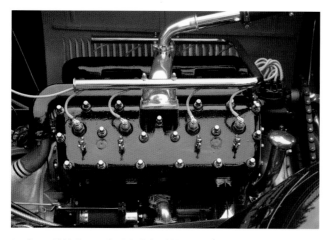

top, Stutz, 1920; bottom, Daniels, V-8, 1921

top, Buick, Custom, 1948; bottom, Stutz, 1923; opposite, Hudson, 1913

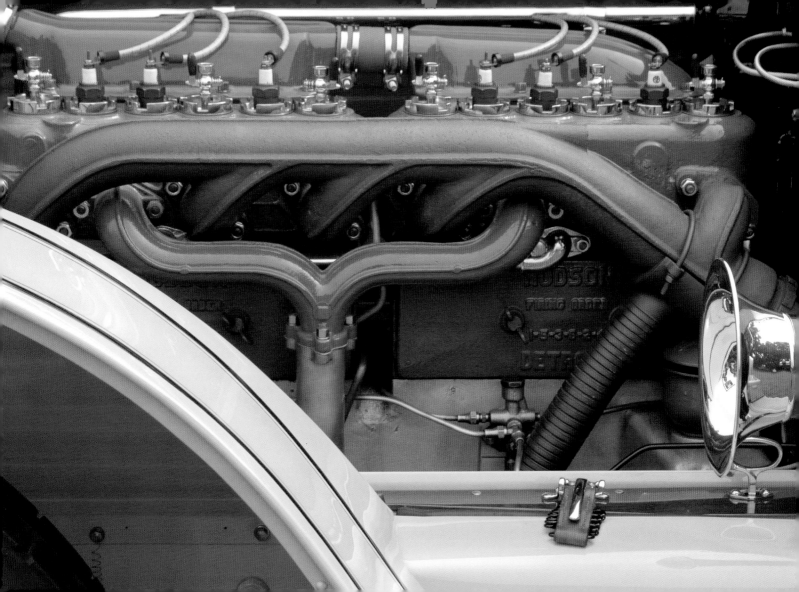

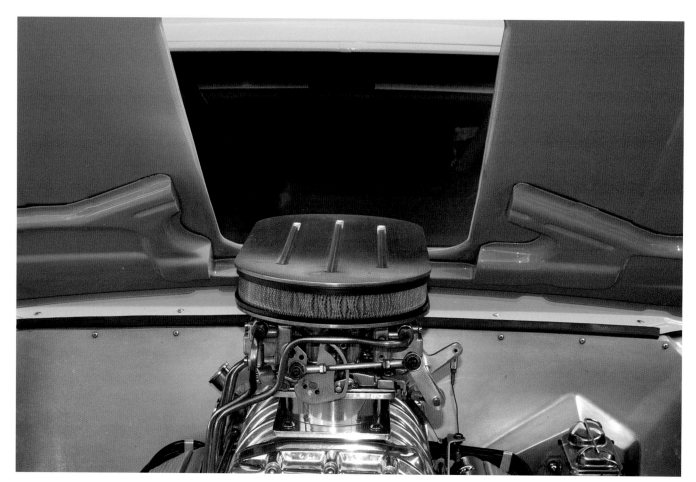

326

Oldsmobile, Custom, 1966

Chevelle, Custom Rod, 1966

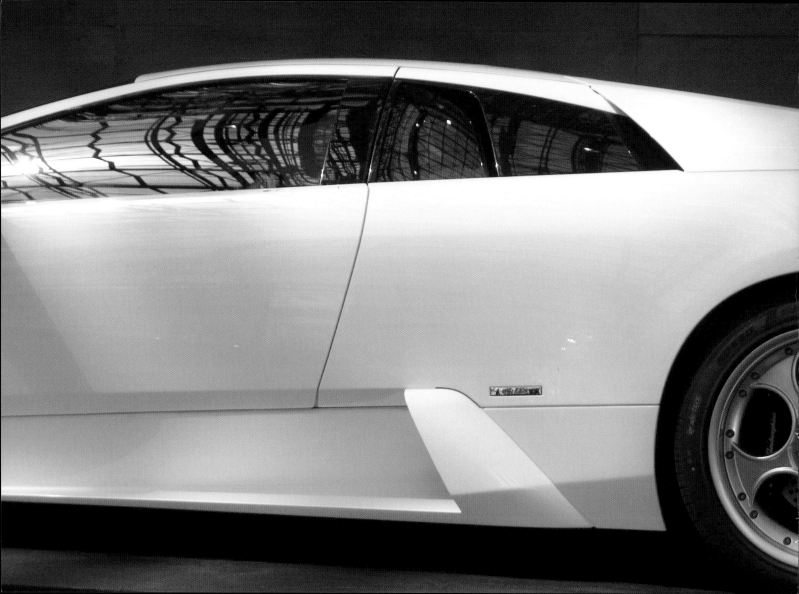

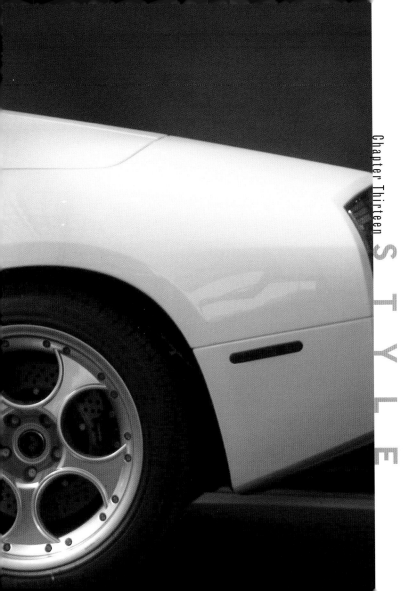

STYLE

Viewed from a distance, the very best cars exude a quality that can only be called style. The same talent that perfected the early auto's engine also gave these sprightly descendants of the carriage their four-square proportion and grace. Later classics may be called "rolling sculpture" or simply good product design. And it is true that style without quality can be a cynical selling tool. But because they are expressions of speed and power, even of fashion and pride, they are much more than just machines. They are carchitecture.

Lamborghini, Murcielago, 2004

Packard, 1926

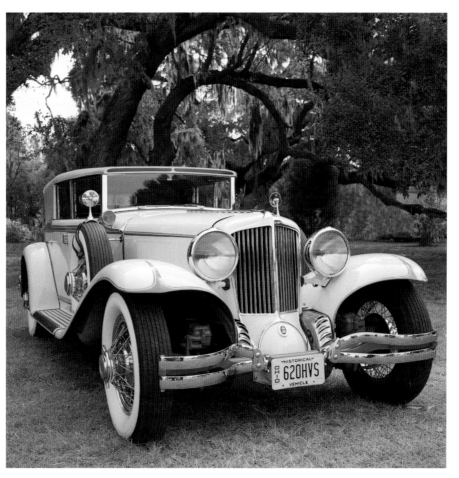

Cord. L29 Phaeton. 1931

Cord, L29, 1929

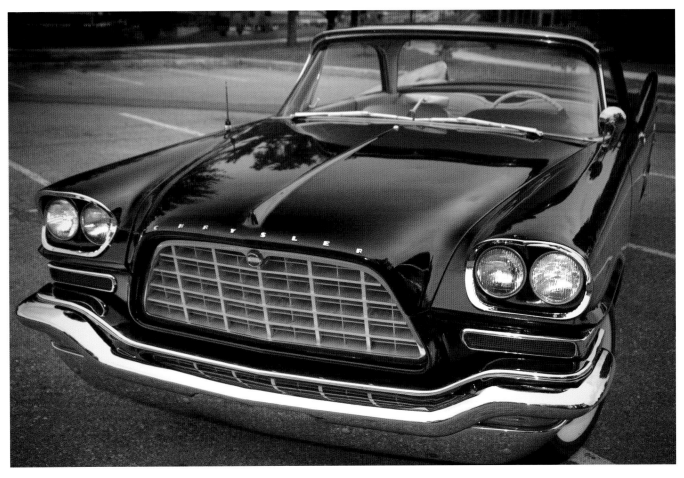

Chrysler, 300C, 1957

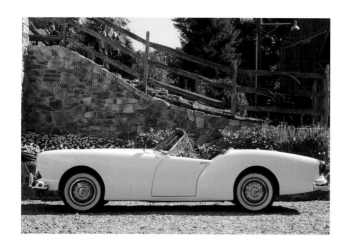

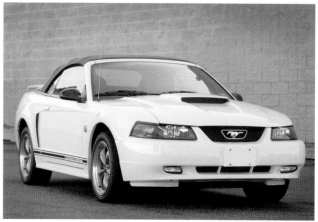

top, Kaiser, Darrin, 1954; bottom, Audi, A8L, 2006

top, Ford, Mustang GT, 2003; bottom, Chrysler, 300C, 1957; opposite, BMW, Z4, 2005

Studebaker, Champion, 1952

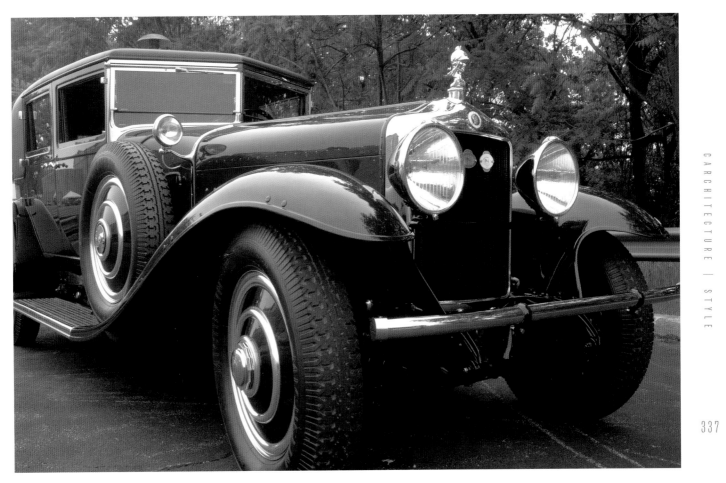

Minerva, Knight, 1926

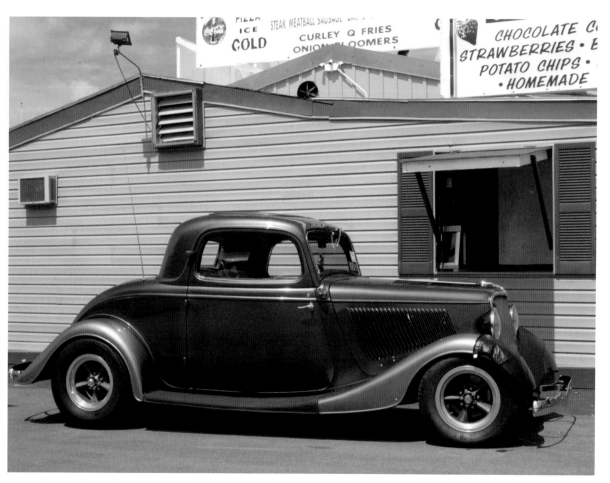

338

Ford. Hot Rod. 1934

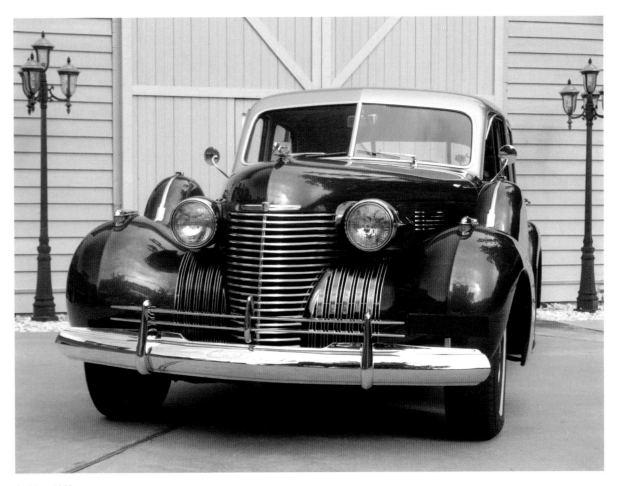

Cadillac, 1940

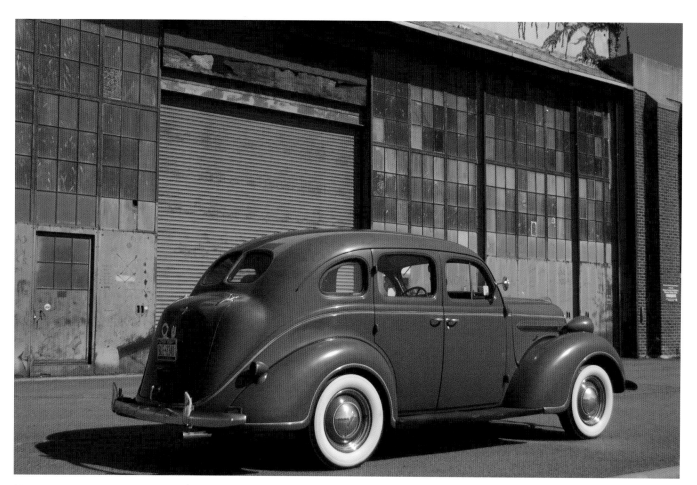

Plymouth, 1937; opposite, Kaiser, Darrin, 1954

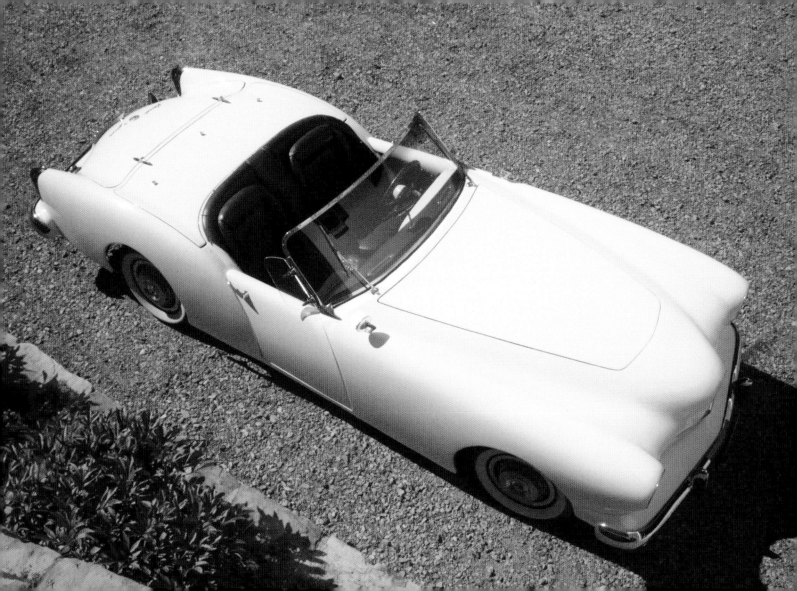

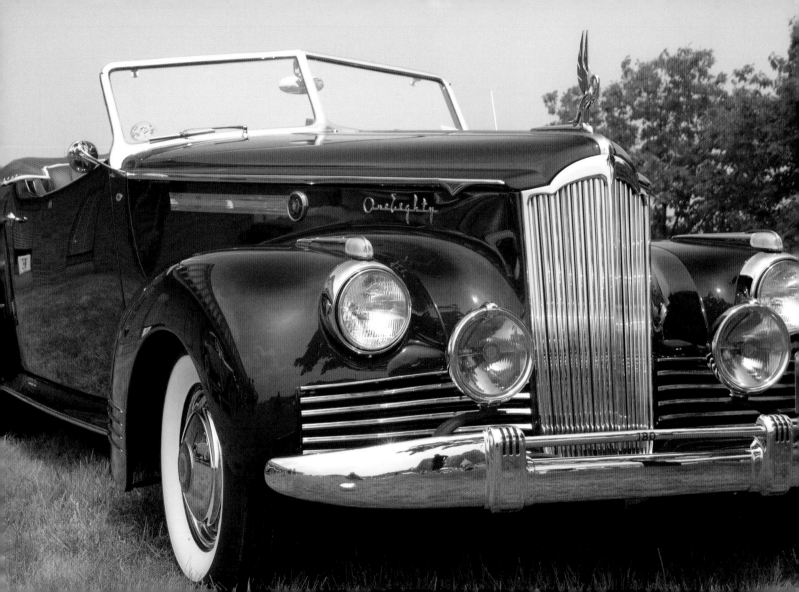

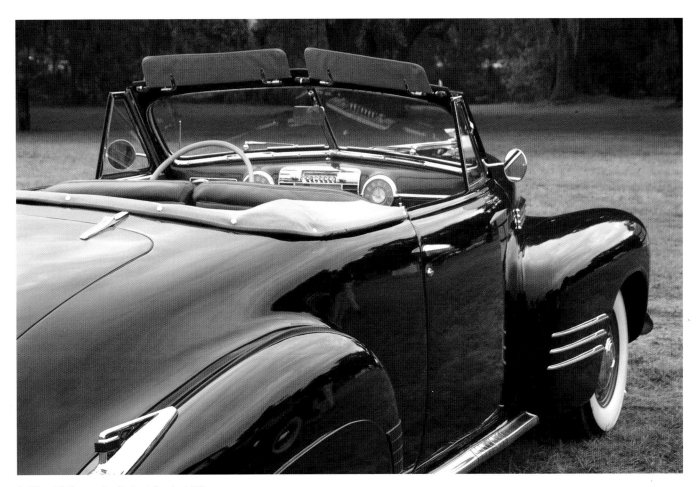

Cadillac, 1941; opposite, Packard, Darrin, 1942

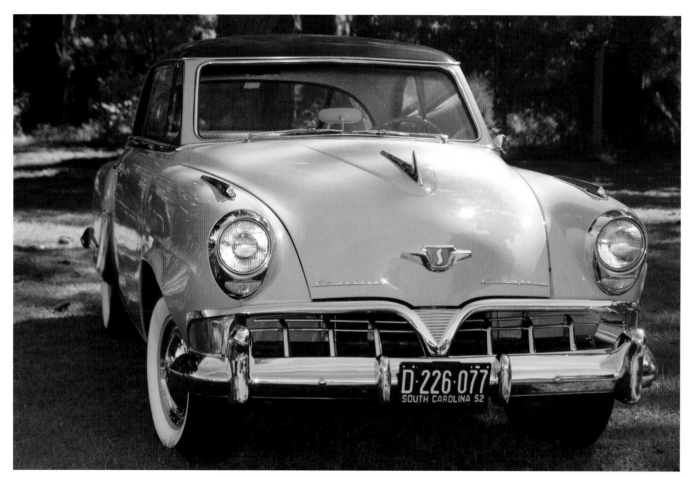

344

Studebaker, Champion, 1952

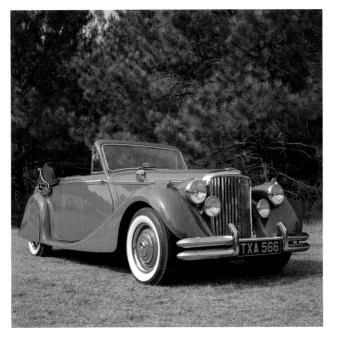

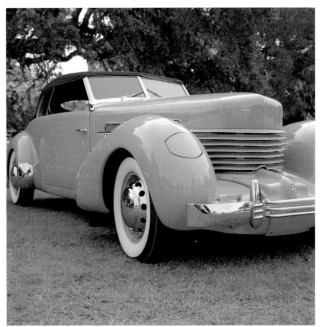

Jaguar, Mark V Drop Head, 1950

Cord 812, 1937

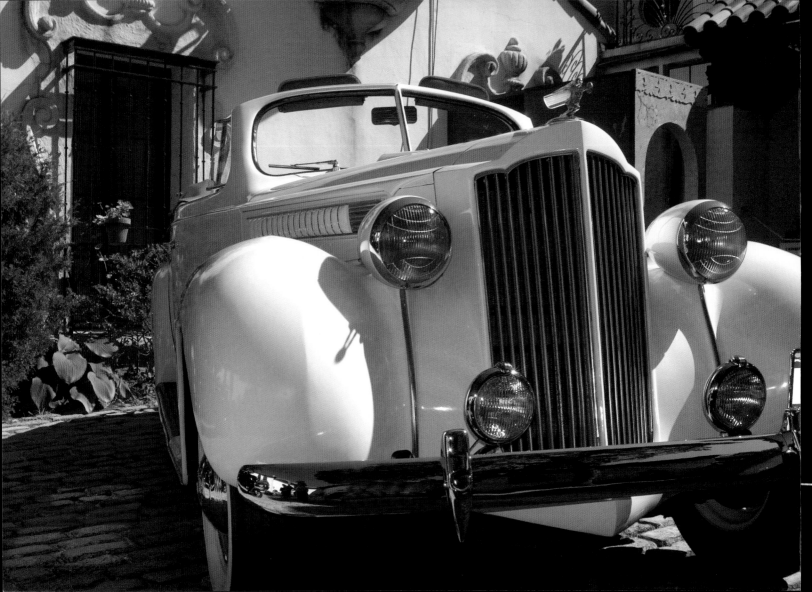

Pope Toledo, Racer, 1904; opposite, Packard, 1939

Stutz, 1923

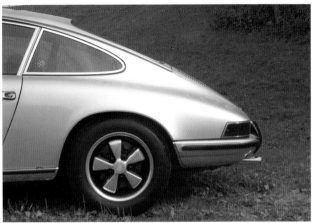

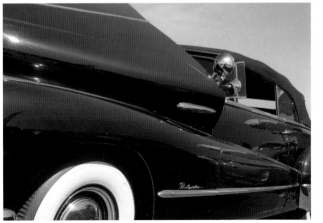

Praga, 1930s

top, Porsche 911, 1969; bottom, Buick Roadmaster, 1948

Alfa Romeo
6C 1750, 1929, **155**
Giulietta, 1963, **96**
Alvis Speed, 1930s, **78**
Anglia, 1948, **96**
Aston Martin Le Masstif, 1933, **186**
Auburn
Boattail, 1932, **181**
Speedster, 1932, **50**
V-12, Boattail, 1933, **52**
Audi
1930s, **212**
A8L, 2006, **334**
S4, 2002, **129**

Bangle, Chris, **17**
Banham, Reyner, **14**
Bauhaus, **12**
Bentley Speed 8 Racer, 2003, **127**
Beuhrig, Gordon, **11**
BMW, **17**
327, 1937, **146**
328: 1936, **46**, **98**, **204**, **297**;
1937, **57**, **275**
1971, **117**
Mille Miglia, 1940, **8**
Z4, 2005, **335**
Breese, 1911, **232**, **253**
Brewster, **12**
Bugatti
T35B, 1928, **319**
T37A, 1929, **316**
T-57C, 1936, **33**, **221**
T-59, 1934, **197**, **198**
Type 35 Racing Wheel, 1924, **18–19**
Veyron, 2004, **303**
Buick
1931, **21**, **94**
1938, **107**
1941, **172**
1942, **78**

1948, **236**
1955, **177**
Custom, 1948, **324**
Riviera, 14; 1965, **75**

Cadillac
1903, **28**
1927, **288**
1938, **293**
1939, **110**
1940, **339**
1941, **343**
1947, **151**, **206**, **257**
1958, **130**, **170**
1959, **82**, **140**, **163**, **241**
1961, **16**
1976, with 1959 fin, **48**
Eldorado, 1953, **270**
Eldorado Seville, 1956, **120**
Model A Sports, 1903, **217**
Series 62, 1941, **25**, **62**
V-8, 1933, **183**
V-16, 1938, **85**
Chevrolet
1932, **255**
1938, **186**, **317**
1940, **102**, **137**, **224–25**, **250**, **284**
1947, **247**
1951, **246**
1957, **267**
1960, **125**, **280**
1963, **281**
Bel Air: 1955, **195**; 1957, **202**, **271**
Camaro: 1960s, **21**; 1969, **178**; 1970,
194; Z-28, 1973, **150**
Chevelle: 1970s, **104**; Custom Rod,
1966, **327**; SS, 1969, **146**, **158**;
SS396: 1968, **130**; 1969, **222**
Corvette, **14**; 1954, **105**; 1957, **122**;
1959, **138**
Custom: 1940s, **289**; 1960s, **323**

Custom Hot Rod, 1939, **223**
Deluxe, 1951, **90**, **101**
Hot Rod: 1934, **164–65**; 1938, **272**
Low Rider, 1971, **92**, **103**, **158**
Master Deluxe, 1936, **187**, **251**
Monte Carlo, 1972, **114–15**
Monte Carlo Modified, 1996, **29**
Nomad, 1955, **74**
Parts, 1957, **222**
Special Deluxe Custom Rod,
1940, **310**
Chrysler, **13**
4-12 Concept, 2004, **162**
300, 1955, **146**
300B, 1956, **200**
300C, 1957, **238**, **333**, **334**
300K, 1964, **209**
1932, **261**
1955, **237**
1961, **148**, **229**
Airflow, 1935, **55**
Imperial: 1931, **124**; 1932, **231**;
1933, **156**: Official NYC Parade Car,
1952, **291**
"K" car, **14**
ME 4-12, 2004, **269**
New House, 1931, **86**
New Yorker, 1956, **134–35**
Prowler, **17**
PT Cruiser, **17**
Viper, **17**
Cooper
Monaco, 1960, **63**
T-51, 1959, **204**
Cord
810, 1935, **11**
812, 1937, **345**
L29, 1929, **54**, **70**, **154**, **332**
L29 Phaeton, 1931, **331**
Custom, 1930s, **295**

Daniels, 1921, **62**, **262**, **324**

Darracq/Talbot Lago T-150C, 1938, **26**,
57, **60**
Delahaye 135M, 1937, **49**, **50**
Denman tire, 1920s, **211**
DeSoto, 1959, **175**
Dodge
1923, **30**, **37**, **287**
1970s, **145**
Magnum 440, 1967, **182**, **183**
Superbee, 1970, **307**
Duesenberg Prototype, 1936, **228**

Earl, Harley, **13–14**, **14**
Edsel Ranger, 1960, 190–91, **267**

Ferrari
500, Mondial, 1957, **297**
512S, 1969, **126**
Fiat
124 Racer, 1968, **195**
1923, **222**
Ford, **13**
3 Window Coupe, 1934, **203**
1932, **264**
1934, **311**
1937, **13**, **88–89**, **131**
1940, **110**
1947, **230**, **298**
1949, **97**
1950, **283**, **293**
1956, **160**, **201**
1957, **149**
Anglia, 1948, **71**
Bronco Concept, 2004, **143**
Custom: 1930s, **87**, **124**; 1933, **95**;
1937, **166**, **169**, **183**; 1951, **112**
Custom Hot Rod: 1930s, **27**; 1933,
6, **278–79**
Deluxe Coupe, 1939, **42–43**
GT 40 Concept, 2006, **180**
GT Concept, 2004, **83**

Hot Rod: 1930s, **93**, **315**; 1932, **186**,
277; 1934, **186**, **338**
Model 40 Special, 1934, **178**
Model A: 1930, **37**, **57**, **120**, **272**;
1934, **39**
Model T: 1911, **157**, **218**; 1927, **121**,
254; Hot Rod, 1920s, **152**
Mustang: 2000s, **65**; GT, 2003, **334**
Police Car, 1947, **109**
"Rat Rod," 1930s, **310**
Reflex Concept, 2006, **40**
Roadster, 1932, **113**
Station Wagon, 1946, **78**
Taurus, **14**
Thunderbird: 1956, **208**; 1958, **296**;
1962, **108**, **161**
V-8, 1936, **210**, **290**
Victoria, 1956, **213**
Franklin
1905, **272**, **314**
Club Brougham, 1932, **51**
Frazer, 1947, **193**

Gallardo, 2004, **189**
Garford Six-Fifty G-14, 1912, **38**, **173**
General Motors, **11**, **13–14**
Graves, Michael, **17**
Gropius, Walter, **12**

Headlight, 1920s, **33**
Hillegass Racer, 1956, **297**
Horch 855, 1938, **283**
Hudson, 1913, **2**, **130**, **176**, **325**

Jaguar
Mark V: 1950, **96**, **170**, **256**, **308**;
Drophead, 1950, **61**, **272**, **345**
SS, 1948, **106**
SS1, Airline Coupe, 1935, **35**, **38**
XK-150, 1960, **31**
XK-180, **52**; 1999, **284**

Kaiser
 Darrin, 1954, 64, 139, 334, 341
 Manhattan, 1951, 80
 Virginian, 1949, 245
Keats, John, 14
Kurtis Custom, 1937, 110

Labourdette, 12
Lagonda
 1930s, 23
 1939, 252, 274
 Rapide, 1939, 153
 T7, 1934, 184
Lamborghini
 Gallardo, 2004, 41
 Murcielago, 189; 2004, 328–29
LaSalle, 1927, 13–14
Le Corbusier, 12
LeBaron, 12
Lincoln
 1924, 102, 154, 215
 Zephyr, 1939, 284
Lister Jaguar, 1958, 195
Locomobile Berline, 1914, 30
Lotus
 7, 1965, 72
 Elise: 2003, 302; 2005, 81
 Exige, 2000, 268
 Racer, 1960s, 53
 XI, 1957, 116
Lozier
 1913, 77
 Runabout, 1913, 173

Marmon
 1920s, 23
 1931, 239, 304–5
Maserati
 6CM, 1937, 318
 A6GCS, 1950, 322
 TNC-2, 2004, 15

Mays, J., 17
Mazda Miata, 2004, 128
Mcier, Richard, 17
Mercedes Benz
 320, 1938, 264
 500K, 1934, 248–49
 540K, 1938, 57
Mercury
 1950, 267
 1951, 10, 56
 1959, 170
 Custom, 1950, 100, 171, 293, 301
 Turnpike Cruiser, 1957, 136
 Windshield Visor, 1950, 174
MG
 KN Special, 1934, 72
 MGA Sebring, 1961, 130
 TB Special, 1939, 36
 TC, 1949, 72
 TD, 1953, 118, 308
Minerva
 1931, 232
 Knight, 1926, 337
Mitchell, Bill, 14
Mitsubishi Eclipse Spyder, 2004, 142
Morgan
 +4, 1960s, 212, 216
 4/4, 1959, 72
Mulliner, 12
Murphy, 12

Nader, Ralph, 14
Nascar Chevrolet, 2000s, 195
Nash
 1935, 20, 76
 1950, 52
 1954, 227
Nissan
 Titan Truck, 2004, 306
 Urge Concept, 2006, 300

Oldsmobile
 Custom, 1966, 326
 Futuramic, 1950, 263
 Hot Rod, 1939, 186

Packard
 1926, 110, 286, 330
 1929, 52, 260
 1939, 346
 1940, 146
 1941, 102
 1948, 119, 293
 1951, 68–69, 244
 Darrin, 1942, 342
 "Swan," 1950s, 244
 "Woody," 1951, 52
Packard, Vance, 14
Panhard Dynamic, 1938, 58, 84
Peerless Green Dragon Racer, 1904, 205
Philson-Falcon, 1959, 13, 24, 91, 220
Pierce Arrow
 1925, 38, 123
 1935, 266
Pininfarina, 11
Plymouth
 1933, 186
 1934, 179
 1937, 226, 340
 1938, 34, 99
 1939, 66
 1946, 67, 207
 Business Coupe, 1941, 8
 Custom, 1934, 242
 Hemi, 1970, 141
 Hot Rod, 1930s, 233
 Prowler, 1999, 170
 Prowler, 2001, 111
 Racer, 1930s, 33, 204
 Road Runner, 1969, 144
Pontiac
 1958, 234–35

 2001, 132
 Custom, 1930s, 243
 Solstice, 2006, 65
 Starfire, 1958, 273
Pope Toledo Racer, 1904, 38, 199,
 262, 347
Porsche
 356A, 1956, 196
 356B Roadster, 1960, 158, 292
 911, 1969, 349
 914-6, 1971, 168
 1500, 1953, 85, 282
 2006, 267
Praga, 1930s, 349

Rambler, 1904, 258
Renault, 1925, 158
REO, 1907, 28, 222
Riley
 Register Racer, 1934, 204
 Special, 1933, 167
Rolls Royce
 1930s, 212
 Phantom II: 1920s, 33; 1930s, 44;
 1932, 264
 Phantom III, 1938, 52
 Silver Ghost, 1910, 276
Rothschild and Fils, 12

Saarinen, Eero, 14
Saleen S7, 2004, 133
Sandford Grand Sport
 1923, 312
 1927, 22, 321
Shelby Cobra Concept, 2004, 299
Siata 140C, 1953, 297
Simplex Speedcar, 1908, 37, 214,
 219, 320
Stanford, 1927, 59
Studebaker
 1934, 78

 1941, 240
 1952, 140
 Avanti, 1963, 62
 Champion, 1952, 265, 336, 344
 Commander, 1931, 47
 Hawk, 1962, 95
Stutz
 1920, 102, 324
 1920s, 23, 45
 1923, 313, 324, 348
 1929, 147, 254
 1931, 183
 Bearcat, 1931, 37, 185
 Blackhawk: 1929, 212, 285; 1930s, 59
 Boattail: 1927, 44; 1929, 192
 DV32 Roadster, 1933, 32
 "Ra" Mascot, 1920s, 239
 Styling the Look of Things, 11
 Sunoco Racer, 1968, 259
 Suzuki GSX-R-4 Concept, 2004, 25

Tad Segar's Racer, 1940s, 73
Telnach, Jack, 14
Terraplane, 1937, 79, 241
Tucker, 1948, 159

Unidentified Racer, 1940s, 264
Unidentified Racer, seen at Lime Rock, CT, 41

Venturi, Robert, 14
Voisin, Gabriel, 12
Volkswagen Beetle, 14
Volkswagen Rabbit, 14

Willys, 1941, 188
Windover, 12
World's Fair (1939), 13
Wright, Frank Lloyd, 11

Yale, 1905, 157, 294

Acknowledgments

In such a limited space, we just can't thank all those whose cars we photographed individually, so instead, we would like to credit those events and venues where many of the autos in this book were exhibited. Those organizations and their mostly volunteer workers deserve high praise for making sure that these automotive treasures are out there for the public to see. Highest praise, of course, is due to the owners and restorers who provide us all with an opportunity to experience this important part of our historical heritage. Our thanks to one and all including:

Ackerly Pond Vineyards, Peconic, NY; the Ann Lee Home Auto Show, Colonie, NY; the Auto Collections Museum, Las Vegas, NV; Berkshire Charity Auto Show, Somerset, MA; Brighton USA Tour, Oldwick, NJ; the Burn Prevention Foundation Concours d' Elegance of the Eastern United States at Bethlehem, PA; the Carlisle Car Collector's Show in Carlisle, PA; Carolina Dreamers Car Club Cruise-ins, Hilton Head Island, SC; Christie's New York; the Colonie Elks Car Show, Elks Club, Colonie, NY; Cruisin' and Oldies Night, Mt. Kisco, NY; the First Annual New York City Concours d'

Elegance; Greenwich Concours in Greenwich, CT; the Hilton Head Island Concours d' Elegance and Worldwide Group Auction; the Himes Museum of Racing Nostalgia, Bay Shore, NY; Long Island Cars Endless Summer Car Show at Belmont Racetrack, Elmont, NY; the Low Country Oyster & Motor Driving Society, Hilton Head Island, SC; Northeast Classic Car Museum in Norwich, NY; the Rolex Vintage Festival at Limerock Park, CT; the Swigart Museum of Huntingdon, PA; the Syracuse Hot Rod Nationals in Syracuse, NY; Vanderbilt Cup Race Centennial, Mitchell Field, NY.

Many thanks, of course, to Marta Hallett, for lighting the fire under this idea, to Signe Bergstrom, for her gentle editing, and to Sarah Morgan Karp, for her elegant design work.